THE GARDEN AT WAR

DECEPTION, CRAFT AND REASON AT STOWE

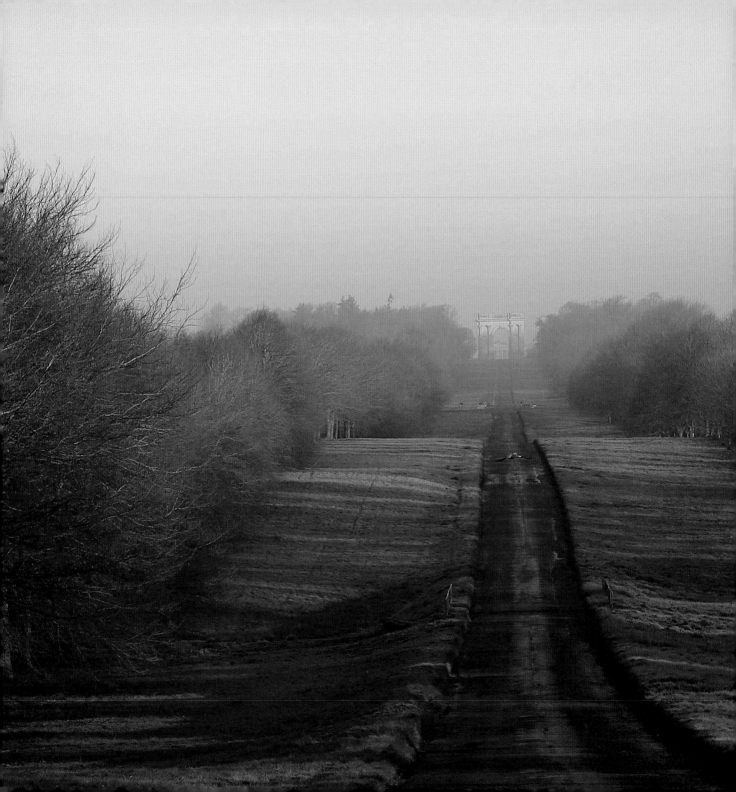

THE GARDEN AT WAR

DECEPTION, CRAFT AND REASON AT STOWE

EDITED BY

Joseph Black

WITH CONTRIBUTIONS BY

Stephen Bann, John Dixon Hunt,
Gary Hincks, Joy Sleeman and John Stathatos

AGANIPPE ARTS
IN ASSOCIATION WITH
PAUL HOLBERTON PUBLISHING 2017

WWW.NICOLAS-POUSSIN.COM

Produced by AGANIPPE ARTS

The development of this project was supported in part by an Art Fund
Jonathan Ruffer Curatorial Research Grant.

ISBN 9781 911300 2 29

British Library Cataloguing in Publication Data

A catalogue record for this book is available from the British Library

Published by Paul Holberton publishing
89 Borough High Street, London SE1 1NL
www.paul-holberton.net

Designed by Laura Parker

Printing by Gomer Press, Llandysul

Front Cover: Corinthian Arch, Stowe (1767)

Rear Cover: Detail of Gary Hincks, *A View to the Temple* (2017)

CONTENTS

QVO TEMPORE SALVS EORVM IN VLTIMAS ANGVSTIAS DEDVCTA
NVLLVM AMBITIONI LOCVM·RELINQVEBAT·

PREFACE

STEPHEN BANN

On 29 October 1975, I travelled across southern England to make a brief late afternoon visit to the garden of Stourhead in its autumnal splendour. I wrote about the experience to Ian Hamilton Finlay shortly afterwards, and received the following reply:

> I am delighted by the description of Stourhead, which makes it very real to me (while eschewing mere Realism). How fortunate that you went at that time of day, and at that time of year. And fancy actually seeing the Pope inscription! That renders the real almost super-real! (One is so accustomed to seeing it in mere type.) The last 'personalized' account of Stourhead which I had, was restricted to the observation – which was accompanied by a great amount of feeling – that it was 'damp'. (Lakes often are.)[1]

It is easy to lose sight of the point that Finlay's knowledge of the great English gardens of the eighteenth century had arrived exclusively at second-hand. It is true that he had experienced one of their Scottish counterparts in the course of his childhood. His son Alec cites "the splendour of Hopetoun House on the outskirts of Edinburgh", where members of his family were employed and he

1
Door to the Temple of Concord and Victory, Stowe (1747)

was "allowed to play in the 'big house'". A later stay in Perthshire familiarized him with the formerly grand Dunira estate, where there was a "ruined formal garden" with "fallen columns".[2] But when he and his wife Sue began to create the garden at Stonypath from the autumn of 1966 onwards he was no longer able to travel. The knowledge of classical gardens that he was accumulating came exclusively through written sources.

In fact, it would be true to say that, by the mid 1970s, there was one major source for his knowledge of the subject that stood out among all others. This was *The English Garden* (1964) by Edward Hyams. He wrote to me on 29 June 1970 of his pleasure in discovering this "FIRST-RATE" study, and added: "I always knew that this book must exist and now I have found it".[3] The reason why the approach of Hyams so excited him was its implicit assumption that "a garden ought to be a work of ART", and not an amalgam of features that derived their character from separate artistic domains, such as poetry and painting. It would be difficult to imagine a more congenial assurance, as he was struggling to establish his own garden, than Hyams's remarkable statement: "An English Garden is an act of praise; it is a manifestation of poetry, and possibly even of religion. It is for this reason, which some will find very fanciful and far-fetched, that I believe that whereas gardening in continental Europe, as in China, is a fine craft, in England and Japan it is an art."[4]

Of course, it was not only Hyams's text that provided this assurance. The mainly black and white photographs by Edwin Smith that accompanied his lively descriptions were of exceptional quality, and must have encouraged him in the quest to find Scottish photographers who would record the developments at Stonypath. There are, for example, around sixteen photographs in sequence that portray aspects of Stourhead, including paintings that recorded (or may have inspired) the design. These are followed immediately by a sequence that documents the features of the other most celebrated eighteenth-century English garden, the Congreve Monument at Stowe, the Temple of Ancient Virtue, the Oxford Bridge, the Queen's Temple, the Rotunda, the Palladian Bridge, the Lake and the Elysian Fields.

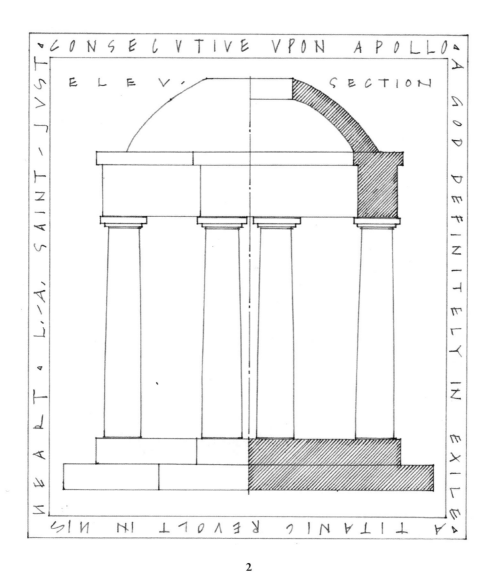

The inscription around the border reads:

CONSECVTIVE VPON APOLLO · A GOD DEFINITELY IN EXILE · A TITANIC REVOLT IN HIS HEART · L.·A. SAINT-JVST ·

Within the drawing: ELEV. SECTION

2

Ian Hamilton Finlay with Mark Stewart, *Design for Temple of Apollo/Saint Just* (1994).
The inscription commemorates Louis-Antoine Saint-Just with phrases quoted from
'Apollo in Picardy' by Walter Pater (1747)

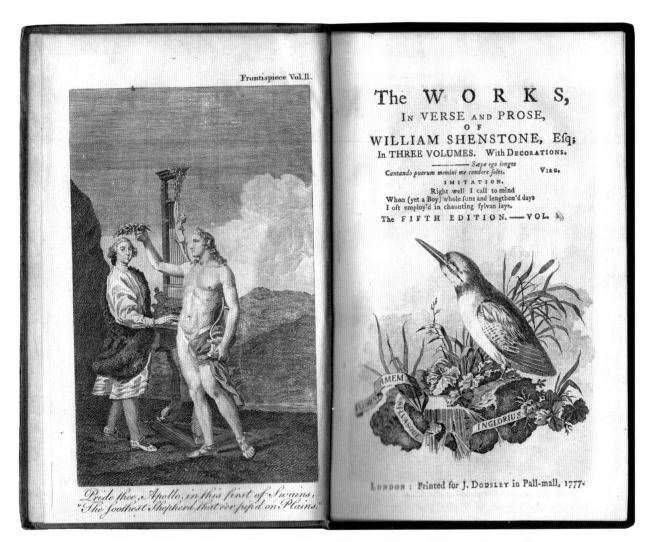

Frontispiece and title page for *The Works of William Shenstone*, vol. II, London: J. Dodsley (1777)

There can be little doubt that both the inspiring text, and the visual record, of Hyams's study helped to galvanize the creation which had emerged by the beginning of the following decade as Little Sparta. Maynard Mack's book on Alexander Pope and his garden at Twickenham, and Erwin Panofsky's essay on the tradition of 'Et In Arcadia Ego', also played their part. But Hyams also included a brief mention of another eighteenth-century gardener, of a rather more modest standing, which may have intrigued Finlay at the time. He quoted a suggestive little text on how 'an avenue can be made to appear longer than its true length'.[5] This was taken from 'Unconnected Thoughts on Gardening' (1764) by William Shenstone. For Finlay, there would have been no direct way of obtaining this tantalizing source in 1970. But by 1975 the situation had changed. It had been anthologized in the collection of texts assembled by John Dixon Hunt and Peter Willis under the title *The Genius of the Place*.[6]

When I was commissioned to write the first comprehensive account of the development of Finlay's garden for John Dixon Hunt's newly founded *Journal of Garden History* in 1981, it was William Shenstone whom I took as my explicit historical model. I entitled it, in homage to the publisher Dodsley's contemporary text on Shenstone's The Leasowes, 'A Description of Stonypath'. The comparison was simple to explain by bringing Stowe into the equation:

> Modest in scale – particularly for those who had previously bowled around Stowe in a barouche – Shenstone's garden surprised and enchanted its visitors with the finesse and variety of its features …. Stonypath is also the garden of a poet, and its fame and influence has already spread beyond the unresponsive environment which surrounds it.[7]

For the Finlay of Little Sparta to be celebrated in this exhibition at Stowe is a fulfilment that one could hardly have imagined all those years ago. But Joseph Black's initiative returns us to some of the first sources of his inspiration.

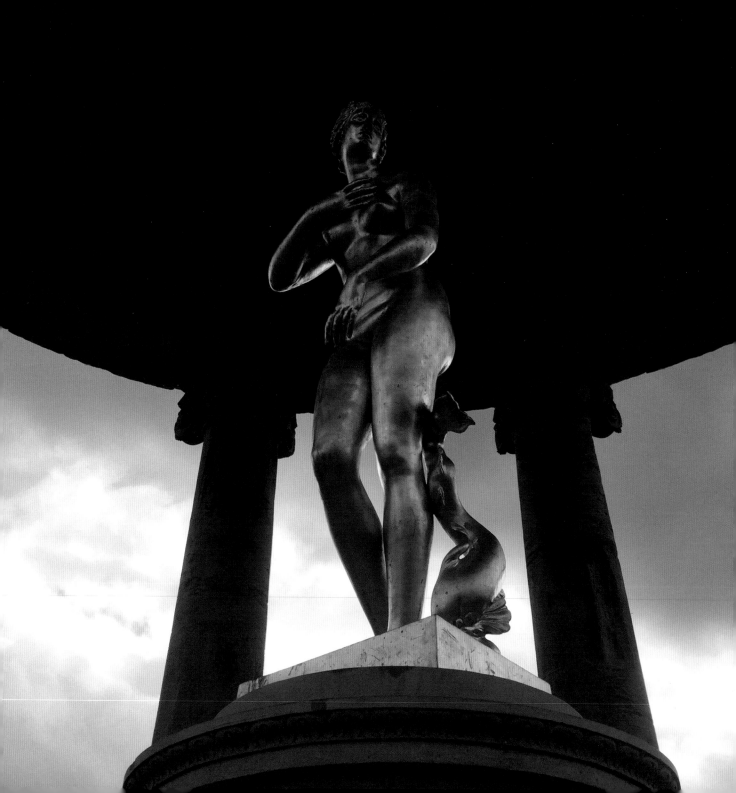

INTRODUCTION

The idea of the garden, as something more than a pleasant retreat, inevitably evokes the eighteenth-century gardens of Stowe in Buckinghamshire. This was a time of classical revival, when the prevailing attitude was to reform the world on the basis of venerated classical ideals. The Enlightenment provided a cultural environment which called for a form of art suited to this 'Age of Reason'. The proponents of such a movement saw the potential of the garden as a symbolic embodiment of civilization and of man's relationship to nature. The garden suggested an Arcadia, a stage for philosophical thought, and, just as irrationality may be conquered and turned to logical reasoning, so too the wild forces of nature may be brought into quiet alignment.

This is the use of the garden as metaphor. In its principles of balance and symmetry the neoclassical gardens of Stowe create a visual equivalent of coherent thought. When one considers the garden in this manner, its relationship with nature implies an issue of mimesis and techniques of reproduction; both of these have been central to the philosophical and aesthetic underpinnings of Western art since the classical age.

The entire garden is an artifice of nature, and one in which the viewer is allowed to interact both visually and conceptually with its rhetorical devices.

4
Venus in the Venus Rotunda

Like a precursor of conceptual art, the attacks in the gardens at Stowe are themselves rhetorical and should be understood within this context. Stowe is not a garden of flowers or shrubs; it is a garden of ideas.

The Garden at War: Deception, Craft and Reason is an exhibition which explores the use of neoclassical gardening practices from the influence of the classical world to the work of conceptual artists, with reference to the French landscape paintings of Nicolas Poussin and Claude Lorrain, whose own distinct pictorial visions gave rise to an unmistakable relationship between the garden, the viewer and the natural world.

Stowe is a garden where politics, philosophy and horticulture are all deeply interwoven into a grand metaphorical landscape. The gardens are best seen as an extended metaphor underpinned by an interpretation of nature modified by human action.[1]

Like many gardens, Stowe is a creation born from the shared will of a group of artists. Although gardeners and architects have had the most visible effect on the land, its primary instigator was a man well accustomed to winning territory over foreign invaders. The garden, for Field Marshal Richard Temple, was another battlefield in which to fight. It should come as no surprise therefore that the gardens at Stowe are deeply suggestive of ideas of both attack and defence.

As one may consider the task of maintaining the supremacy of logical reasoning an ongoing battle, so too the garden is a site of perpetual conflict between nature and the scope of man's control.

At Stowe, two hundred and fifty acres of carefully maintained gardens offer a complex web of views, pathways, statues, inscriptions, urns and ideas. Unlike its French floricultural precursors, Stowe presents sudden shifts of scene, and sometimes the same scene viewed from a different perspective; abrupt revelations, as well as spots in which to stop to absorb the visual effect. At Stowe the viewer is forced into the role of an active participant.

5
View of the South Front Portico of Stowe House

The first and perhaps most obvious question that arises for the visitor to the garden has to do with perspective, point of view and positioning. Its two primary entrances present immense stretches of pathway leading towards the gardens. It is clear from this early invitation that the landscape here has been arranged around the viewer, rather than through the variable, indiscriminate forces of nature. Stowe therefore asks of the spectator, where and how do you situate yourself, figuratively and literally, with respect to the intricate and multilayered structure as a whole, and in relation to each particular temple, view and idea?

These reproductions of nature recur continuously in the garden design. They are particularly apparent in imitations of an idealized thing or scene. The careful construction of passages of landscapes is evocative of an intentionally deceptive reality. The garden's synthetic views of the landscape are designed to clarify how and what we see. We are left ourselves to interpret what this may suggest and, thanks in part to the ready-made's implicit critique, we can understand that all reality in art is mediated via representation and context.

As if presented with a work of conceptual art the viewer is both physically and cognitively enveloped. For instance, as one approaches down the immense stretch of the Grand Avenue, the distant gardens are visible through the rise of the Corinthian Arch. As one approaches the gardens in this manner a subtle elevation in the topography of the road allows the far distant house at Stowe to rise within the centre of this immense structure. The visual positioning of these two distant objects coming into alignment is like the iron sight of a gun being primed for firing, with the Avenue suggesting both barrel and firing range. The arch, and its distant companion, may also bring to mind the motte and bailey castle, implying a drawbridge barricading a garden fortress.

The Corinthian Arch can be seen as a visual and conceptual framing device for the garden. It presents a bellicose view through a reconstructed classical tradition to a stage-set for political, philosophical and poetic thought.

6
Temple of Concord and Victory (1747)

The Garden at War presents Stowe as a site of perpetual conflict in which the preconditions of destruction and creation are inescapable. If nature is understood to be original, then the garden is perhaps an ordered but un-orderly condition; a re-ordered vision of the natural order; a vision of nature disciplined by human action in an attempt to advance and gain control.

It is no wonder then that Stowe continues to speak to and inspire artists. Its designers shared a preoccupation with both the social and the ethical life of human beings and, in doing so, spoke to something deep-rooted in Western art. Stowe is not just an artistic achievement in its own right, but a set of potentials waiting to be realised in the work of others as well as in the engaged imagination of its viewers.

If the work of contemporary artists gives us the opportunity to gauge the scale of Stowe's achievement they suggest something else as well, that Stowe is a place which we are still learning to read and one whose achievement will stand the test not only of time but of different interpretations.

This exhibition publication brings together an arrangement of interpretations and theories. It is a collection of elucidated thoughts and related material designed to offer the reader a narrative and point of departure and review for the ideas I have suggested here. A collection of this kind does not have a single purpose, nor argument to make, nor historical reading to advance. It is intended to help the spectators of Stowe enjoy and think further about the place and its place in history. The suggestion of the juxtaposition of text and image is taken up in a number of essays in this book and underpins an engagement with the utilization of words by visual artists.

For this publication the artist and illustrator Gary Hincks has been commissioned to produce a series of drawings showing large installations by Ian Hamilton Finlay situated within certain areas of the gardens at Stowe. The 'proposals' in question have been conceptualized, as they could not be realised in real life, yet are intended to respond to a series called 'Six Proposals for the Improvement of Stockwood Park Nurseries in the Borough of Luton' made by Finlay in collaboration with Hincks in 1986.

The original series showed ideas for work by Finlay inserted into idealized, painted landscapes by Claude Lorrain. The camouflaged *Aphrodite of the Pastoral*, showing a *Venus de' Medici* in American army uniform, parallels and wittily combines two forms of representation, and perhaps suggests that both are equal forms of dissimulation.

This is a theme which recurs in 'Perhaps, a Stowe', written and illustrated by John Dixon Hunt. In the essay he reflects on the visual comprehension of Stowe through its relationship to the work of landscape painters. His reading of Stowe broadens the visual horizon beyond its picturesque influences and suggests a broader connection to other artistic and cultural practices. Like this collection of writing itself, he situates Stowe at the centre of deeply relevant and fertile interpretations.

In the essay he touches on the previous works by Hincks and implies a relationship between artists, like that between Hincks and Finlay, which gardens by their nature engender.

Ian Hamilton Finlay was an artist of deep commitment to the classical tradition, who also felt an obligation to return the modern world to the difficulty of understanding some of the most destructive episodes of the twentieth century. The nature of this obligation was at one with the need to remember 'against the grain' of a culture that seemed devoted to ignoring or denying the very things that he wanted to recall.

Finlay was himself a gardener and a poet, who found himself embroiled in his own metaphorical battle of the 'Little Sparta Wars' at his garden in Scotland. Reproduced here is a transcript from an interview he gave in 1989 in which he speaks about the battle, his garden and its wider significance.

Referring to the 'battle' and wider military motifs in Finlay's oeuvre are two short essays written and illustrated by the Greek photographer and writer

7
OVERLEAF
Palladian Bridge (1737)

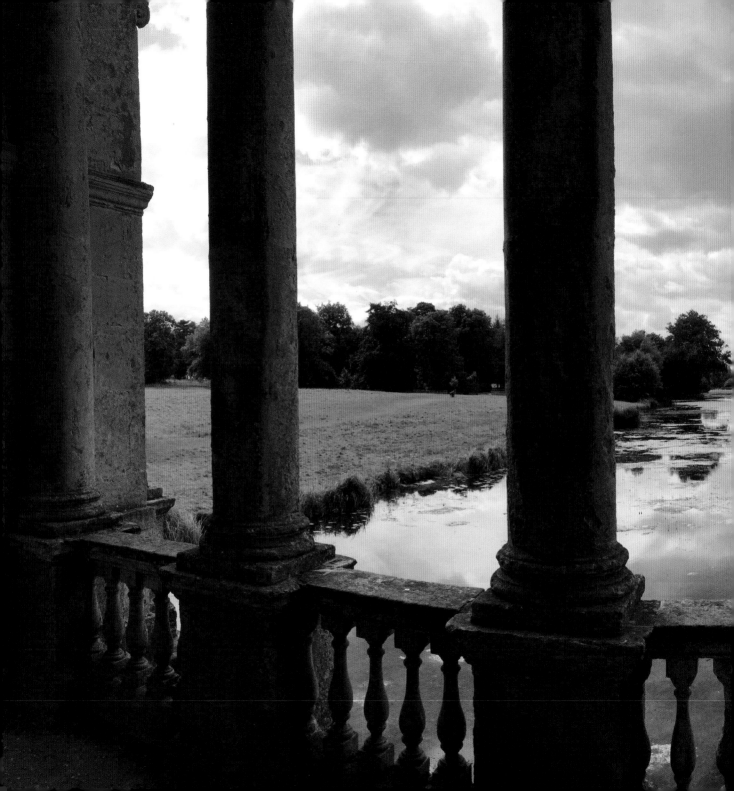

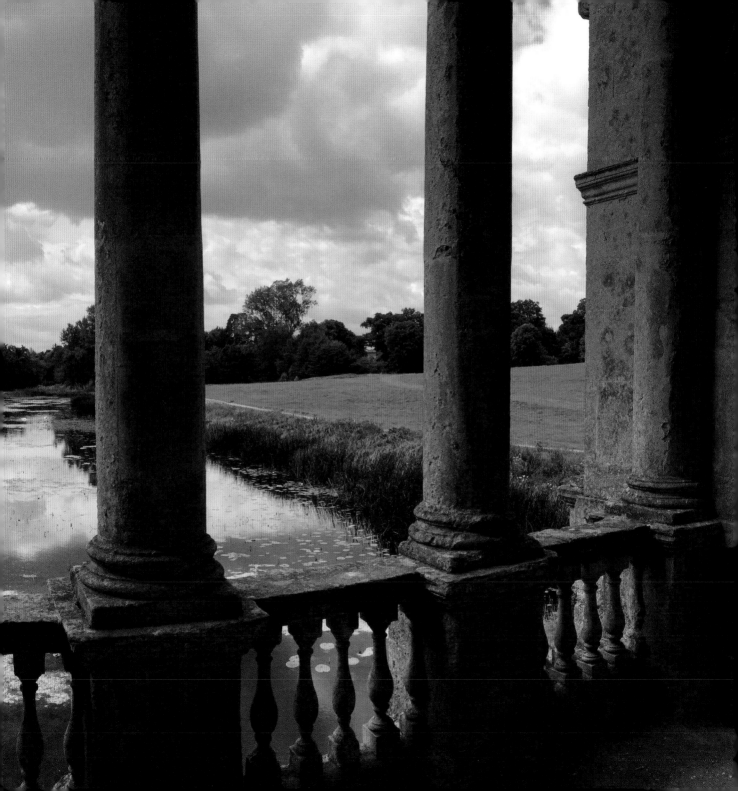

John Stathatos. During the 1970s Stathatos worked as a freelance foreign correspondent specializing in Third-World conflict. His essays 'Piety and Impiety' and 'The Petrified Warships of Little Sparta' were originally published over a decade ago and examine the relationship between the classical tradition, the garden and military iconography. They provide a suggestion that the 'battles' which Finlay fought were, for him, of social and ethical implication. Finlay's war against the bureaucracy of contemporary society can be read as an allegorical war fought from his own classical embattlement.

In the concluding essay, entitled 'Elegiac Inscriptions', Joy Sleeman embarks on a discussion of words in the work of Ian Hamilton Finlay and Richard Long. The essay is underpinned by an understanding of the work of Nicolas Poussin and the pastoral tradition. It offers a reading of the 'poem' as an inevitable inscription of mortality and similarly suggests a relationship between conceptual word art, concrete poetry and the classical inscription.

These analyses of elements that structure our perception of art and of the garden suggest a world of potential for understanding the contemporary relevance of the Stowe. The garden has been understood, and thus utilized to great effect, by a certain number of artists who realised that it is a place continually suggestive of social constructs and subjective realities. As such, Stowe will continue to offer meanings to artists and writers determined to speak about the nature of human activity.

8
Gothick Temple (1741)

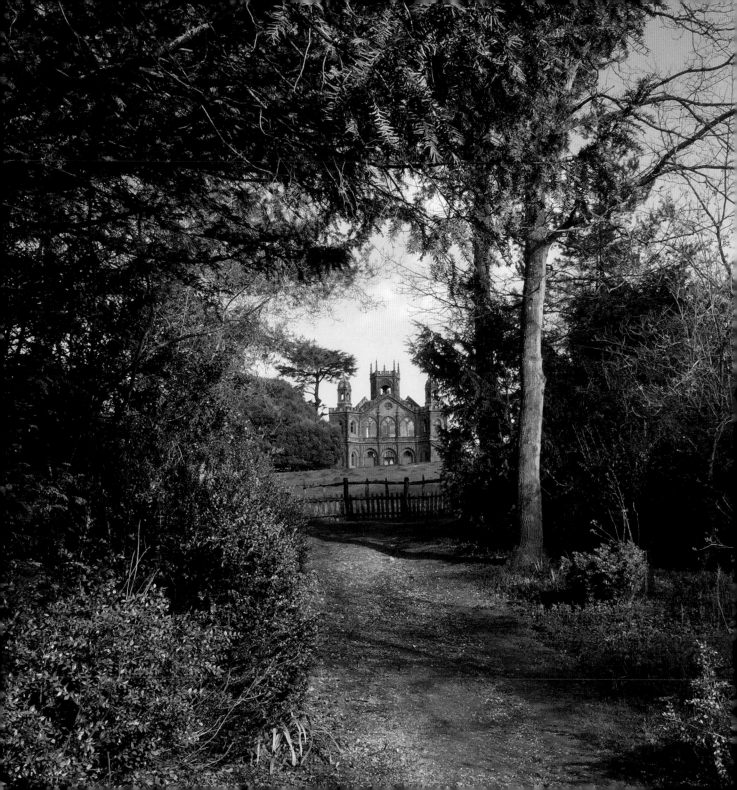

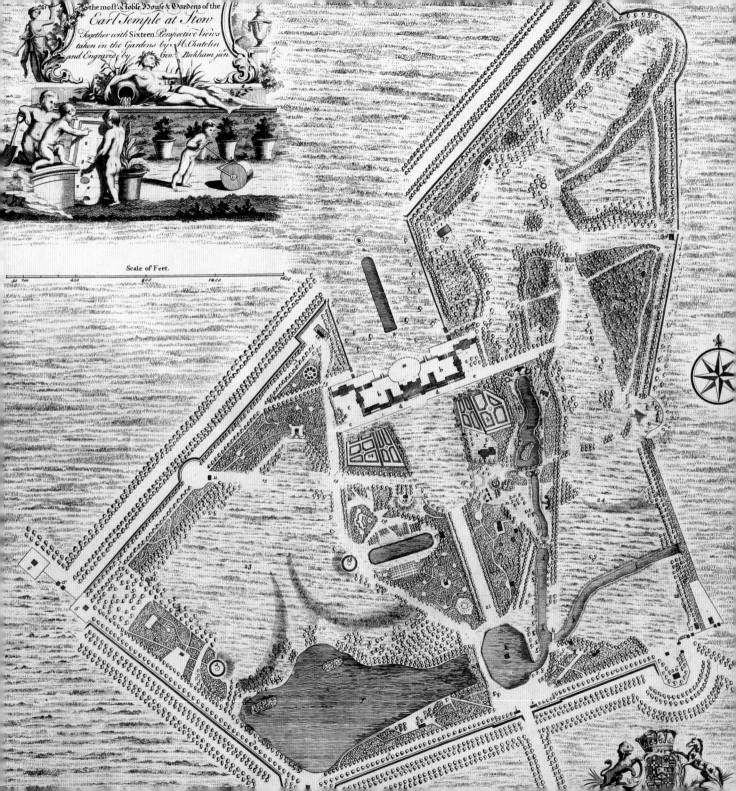

The most Noble House & Gardens of the
Earl Temple at Stow
Together with Sixteen Perspective Views
taken in the Gardens by M. Chatelin
and Engraved by Geo. Bickham jun.

Scale of Feet.

I

A SHORT HISTORY OF STOWE HOUSE AND GARDENS

The gardens at Stowe offer a particularly intriguing example of the way political and philosophical statements can be encoded into a seemingly cosmetic garden design. Rather than conforming to what we today understand as a garden's purpose, Stowe was developed less as a place of withdrawal and seclusion than as a theatre from which its designers could assert their social and political views. Yet to leap ahead to the maturity of the garden as we see it today is to ignore the series of stages by which it has developed.

The person chiefly responsible for the garden's existence was Field Marshal Richard Temple, Viscount Cobham. Lord Cobham, along with the other radical Whigs of the time, had been greatly influenced by the social, moral and political order of republican Rome, which they had encountered on their Grand Tours of the Continent. The Grand Tour of Europe was considered a rite of passage for many of the upper-class nobility, since the experience necessitated an exposure to the cultural legacy of classical antiquity.

The tour's destination was traditionally considered to be Rome, where the traveller could study the ancient ruins and consider at length the cultural legacy of the city. Cobham perhaps saw in the cultural and political influence of the

Printed in London by G. Bickham,
A Map of the Stowe Landscape Gardens, Buckingham (1750), detail

republic a form of power beyond that of militaristic strength. As E.P. Thompson noted, the influence of the ruling-class in the eighteenth century "was located primarily in a cultural hegemony, and only secondarily in an expression of economic or physical [military] power".[2]

Lord Cobham was born in 1675 into a weighty aristocratic lineage. He was the son of Sir Richard Temple, 3rd Baronet, and was educated at Eton College and Christ's College, Cambridge. After becoming a Captain in Babington's Regiment in 1689, he fought under William III during the Williamite War in Ireland and then at the Siege of Namur in July 1695 during the Nine Years' War. Temple succeeded his father as 4th Baronet in May 1697 and as Whig Member of Parliament for Buckingham later that year.

To understand the influence of military design on Stowe's history it is necessary to look first at one of its most influential and more formally inspired gardeners, Charles Bridgeman. Bridgeman's vision for Stowe was to turn the existing gardens into a secured and carefully cultivated space – in essence to turn the garden into a fortress.

Bridgeman designed a grand proposal for an enlargement of the garden. The new scheme called for the gardens to be bounded by a stockade ditch. This mode of garden design seems to have depended, at least in part, on the use of the enclosure known commonly as the ha-ha. The ha-ha represents a particularly noticeable point of connection between elements of European military engineering and the aesthetics of French landscape painting.

The ha-ha was employed widely in eighteenth-century Britain both as a practical device to keep grazing animals from the immediate vicinity of the house and as a means to create a satisfying visual continuity between the house and the surrounding natural parkland. This enabled the feeling of pastoralism which the gardens were evoking without the undesired addition of livestock within the garden.

The ha-has at Stowe are faced in stone, and were probably favoured by Lord Cobham owing to his familiarity with the similar military earthwork fortifications he saw while on service during the Marlborough wars in Europe. With its sharp,

angular corner bastions and the ha-ha surrounding its perimeter, the emerging plan of Stowe strongly resembled the design of a military fortification.

Digging these ditches sufficiently deep and wide to prevent the grazing animals from crossing opened up great panoramic views of the surrounding landscape. Yet what is remarkable to any observer is the striking disparity between the scale of these extensive earthworks and the almost invisible result.

Ditches which were visually obvious or called attention to themselves, even indirectly, would necessarily be recognized as fences, or restraining devices, thereby negating the desired impression of *natura naturata* – nature created by nature. Thus, the ha-ha has to be hidden, and the most effective way of accomplishing this goal of invisible containment was literally to go underground.

Later, William Kent was brought in to replace Charles Bridgeman as architect and chief garden designer. Kent's vision for the gardens extended beyond Bridgeman's more abstract metaphorical suggestion of the garden, implied by the ha-ha design, in favour of stronger ideological statements.

At the time Sir Robert Walpole dominated English politics. Leader of the Whig party, he was the first man to be given the status of 'Prime Minister' and during his twenty-one years in post Walpole accumulated a vast amount of economic and political power.

However, his increasingly overwhelming power, and close relationship to the King, began fostering a sense of concern among the more idealistic Whig members. Walpole's power and relationship with the monarchy was seen to undermine the very notion of democratic order. Following a disagreement with him in Parliament, Walpole stripped Lord Cobham of his military ranking.

Filled with indignation, Cobham began to lay out plans with William Kent to transform his gardens at Stowe into a moral and political statement against Walpole's government. The gardens were thus to be divided along two opposing paths, named Vice and Virtue.

The much famed, and certainly most curatorially elegant passage of this new garden, the 'Elysian Fields', was created between 1734 and 1738/39. They show most clearly Cobham's intentions for the garden. It was divided into three

10
Temple of Modern Virtue (1734–39, removed in the 1770s; only the foundations remain)

11
Temple of Ancient Virtue (1734–39)

areas with the middle ground being the Elysian Fields proper, named after the classical paradise where the virtuous and brave went after death. The Fields contained three temples, the Temple of British Worthies (1734) and the Temples of Ancient and Modern Virtue (1734–39).

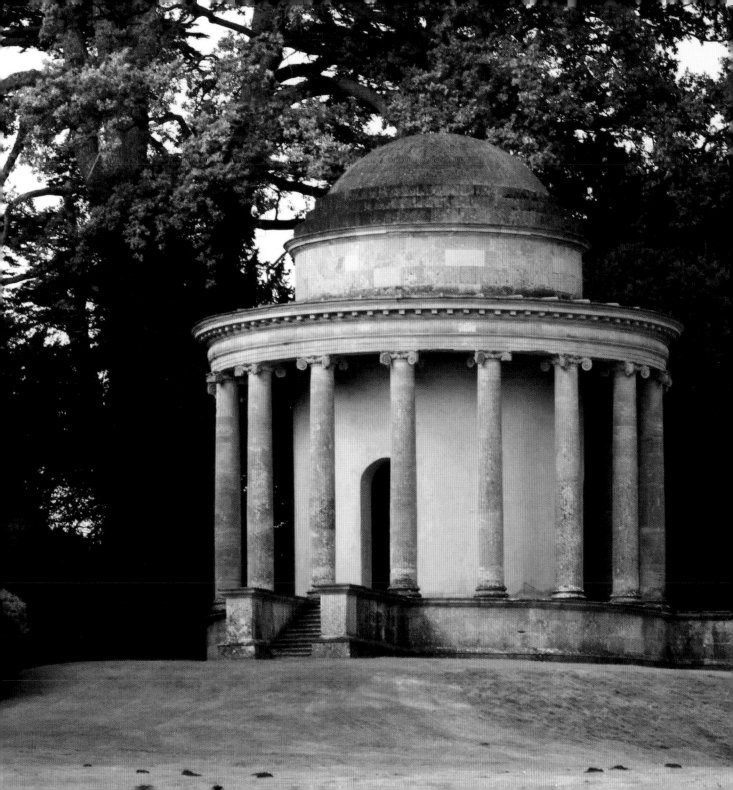

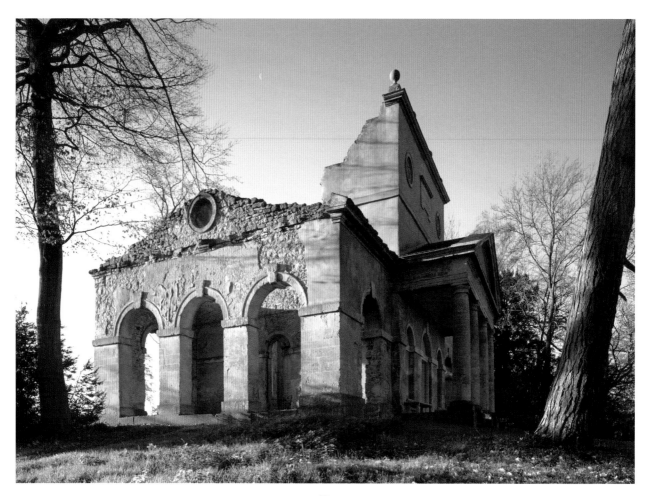

12
Temple of Friendship (1737)

The Elysian Fields were less formally laid out than those of Bridgeman in the main park and were a further departure from the formality of the most popular gardens of the time, like those at Versailles. One reason was that Kent wished to juxtapose an understanding of pastoralism with the existing sense of formality.

In the Elysian Fields, Kent wished to relate three elements symbolized by each of the temples. In turn these temples are each interrelated and thus construct a series of complex meanings. The Temple of Ancient Virtue, standing on the highest point of the Fields, is a solid, classical structure, inspired by the Temple of Vesta at Tivoli. Its companion, The Temple of Modern Virtue, has now been more than euphemistically destroyed. We know through illustrations made of it at the time that it was composed of a chaotic heap of stones which implied the "ruinous state" of modern virtue.

Kent designed Ancient Virtue to contain statues of Homer, Socrates, Lycurgus and Epaminondas. Cobham's choice for these statues reflected an idealized state of social order – respectively a poet, a philosopher, a law-maker and a general. In implied symbolic contrast, Modern Virtue contained a headless figure generally taken to be of Robert Walpole.

The Temple of British Worthies, on the other hand, sitting at the bottom of the Fields, contains a sequence of busts displaying the men whom Cobham took as the most influential thinkers and leaders in recent British history. Dividing the two is the so-named River Styx, an elongated pond which mimics the natural flow of a river through the landscape.

The Temple of Ancient Virtue is placed in a valley associated with a lost Eden. Situated in the Fields, which are to be understood as a place of the dead, the Temple is itself a tomb – a comment on the status of Ancient Virtue in the contemporary world.

13
OVERLEAF
Hawkwell Field

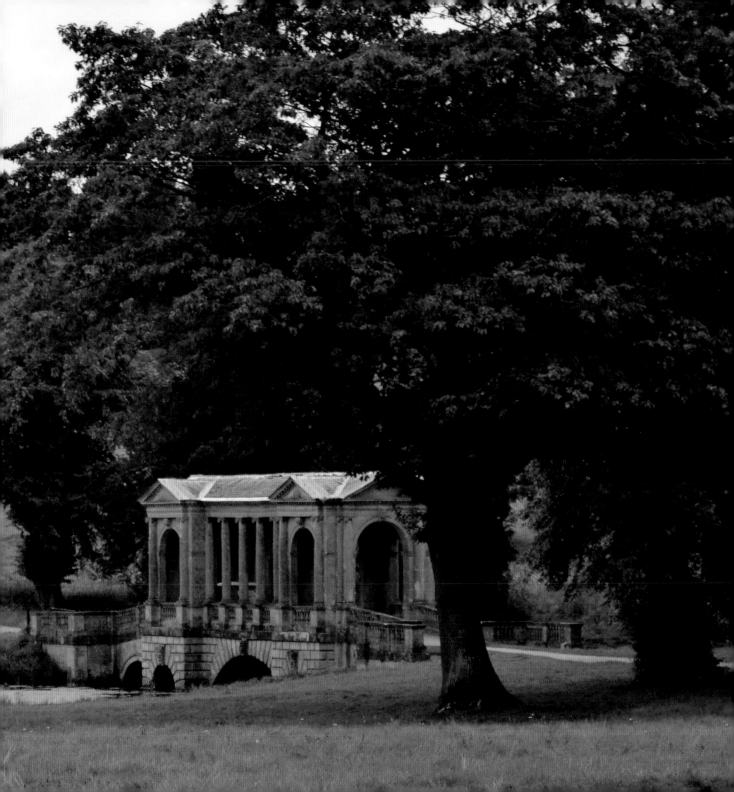

At Stowe Cobham began to nurture a new generation of young, disaffected, Whig party members. They took as their headquarters the Temple of Friendship (1737). On the ceiling was a painting of Britannia surrounded by other figures, one of which held a label with the words *The Reign of King Edward III*, another displayed the words *The Reign of Queen Elizabeth*, and a third had an incomplete title reading *The Reign of* —, the last part of which was covered by Britannia's mantle and which she seemed unwilling to look at.

With this new generation around him, Cobham eventually managed to force a vote of no confidence in Robert Walpole, ending his twenty-year domination of British politics.

Cobham nevertheless continued his gardening ambitions and in the mid 1740s he and a then twenty-five-year-old Lancelot 'Capability' Brown began to develop the Grecian Valley. Planted at one end is the Temple of Concord and Victory (1747), originally known as the Grecian Temple. Atop the temple, on the western side overlooking the valley, are the statues of Victory (in the centre) and of the Liberal Arts of Painting and Sculpture.

The valley itself was made to sweep down towards the Elysian Fields, passing the temple, and framed on each side by trees planted in such a way as to give visual access to other temples and columns in the far distance. Most notable of these is Lord Cobham's Monument, completed in 1749, the year of his death. It was designed as a viewing tower from which one could survey the entire garden. Atop the monument is a statue of its namesake, Lord Cobham himself, who is afforded the opportunity, if only in stone, continually to stand and survey his greatest artistic and political achievement.

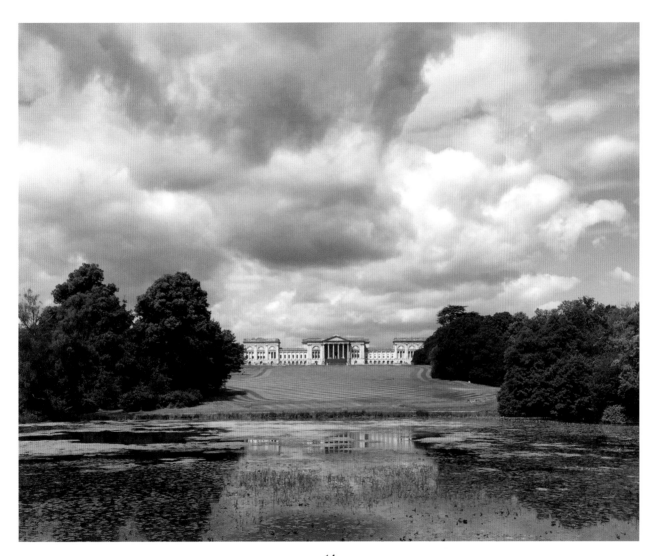

14
View from the Octagon Lake to the South Front of Stowe House

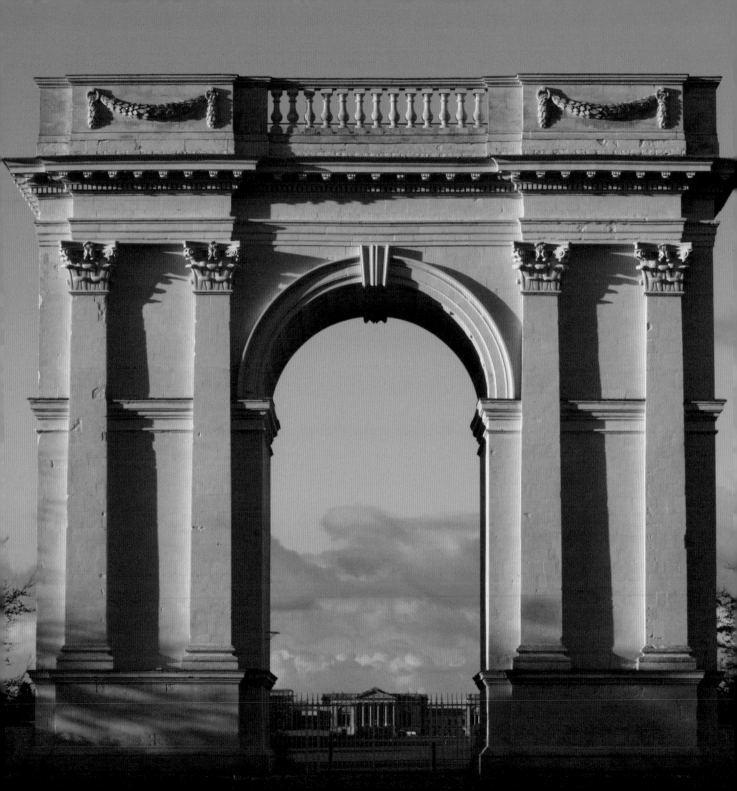

II

THE GARDEN AT WAR

The neoclassical garden stands in contrast to the prevailing contemporary condition of seeing the garden through the view of the Romantics. The view of gardens today is still largely dominated by nineteenth-century gardening practices. The influence of literary culture is Britain has had a significant role to play in sentimentalizing the garden in this way. It is no wonder, for our predominantly Romantic culture, that the practice of gardening is seen as a way of creating beautiful, but ultimately abstract, patterns. It is also no wonder that, particularly in England, the act of being in a garden is seen as essentially a Romantic one.

The 'cottage garden' design depends for its effect on charm and intimacy rather than on grandeur and formal structure. This movement away from landscape design coincided with a broader movement in art, and its popularization in England can be seen as symptomatic of an obsession with class and social interaction. If for the aristocracy in the eighteenth century the landscape was a place to reinforce social status and political power, then for the growing middle classes in the nineteenth century it was a place to do the same for themselves.

The influence of cultural movements of this period, such as those of the Pre-Raphaelites and the Arts and Crafts movement of William Morris, reinforced

15
Corinthian Arch (1767)

the perception of the garden as a place of leisure. The flower garden is intended to be experienced through the perfumed senses and not the clear, analytical mind. Flowers are meant to be appreciated for their aesthetic pleasure as they excite both sight and smell.

By contrast the refined clarity and order in neoclassical gardening practices has the analytic clearness of rational thought. Ideas are expressed and assessed by the thinking mind. While a lot of this art undoubtably has emotive content it is articulated as an object of study. Thought, memory, emotion and aesthetic pleasure are measured, analysed – an object to be first experienced, but subsequently investigated.

Therefore, the neoclassical garden resists the idea of a place of retreat. Its spartan composition, its simplicity and austerity, necessitates the active involvement of the viewer's judgement and visual challenges constantly arise within the gardens to demand this.

It is easy to notice the influence of painting on this style of landscape design. The three-dimensional surface on which the garden sits repeatedly condenses into a two-dimensional image. The effect is like walking round an art gallery full of landscape paintings with views set at intervals along the pathway. Just as a painting is meant to be viewed head-on, certain views within the garden are orchestrated around certain viewpoints.

The positioning of objects throughout the garden is deliberately arranged to harmonize on the focal point at which the viewer stands. In the near ground passages of trees and lakes respond to temples and follies set within the landscape. Like a stage set, it is planned to condense into a two-dimensional image and thus resolve the chaotic and random ordering offered by nature in favour of man's solipsistic view of the universe. It is an attempt to make reality coherent by rendering it as a web of stillnesses. The goal is to present an ideal mode of examining of the landscape; to offer a clear and condensed view of

16
Gothick Temple (1741)

nature for the viewer's comprehension. It is the essence of the neoclassical attitude – reduce, clarify and examine.

The designed artifice of the view, and the harmony between contemporary viewer and ancient form, clarifies the significance of the relationship between view and viewer. The sensation is both harmonic and disconcerting. The landscape has not grown, as landscapes do, through the variable forces of time and nature, but through the careful composing of the landscape designer.

The transformation of the English garden from its traditional Continental formality, the *jardin à la française*, to an irregularly planned landscape garden was a very gradual process. This aesthetic development depended on changes in literature, philosophy and, most importantly, on the compositions of French landscape painters.

The work of painters like Nicolas Poussin and Claude Lorrain presented an idealized view of the natural order. In paintings of this kind, precedence was given to the laws of pictorial composition over a strict or literal observation of nature. Thus, on a metaphysical level, they invited speculation on the role of man in the natural world.

By the very nature of its proximity to the natural world the garden suggests an unavoidable relation of order and disorder, between what can, and cannot, be controlled by man's hand. As such, an important component of these early Arcadian landscapes was signs of ancient civilization dissolving back into the landscape.

17
James Cook Memorial (1778, restored 2002)

It needs scarcely to be said, that an
epitaph presupposes a monument,
upon which it is to be engraven.

CCXLI.
As falls the tree, the tree must lie;
Fixed is the doom of all that die:
The Spirit, then, no longer pleads,
Nor intercessor intercedes –
The day of grace and prayer is fled:
Thus to the living speaks the dead!

Joseph Snow, *Lyra Memorialis; Churchyard Thoughts in Verse,* 1847

III

A PASTORAL ROMANCE INCLUDING DIALOGUE AND VERSE

The most evocative description of an Arcadian landscape conveys a feeling both for nature and of man's place within nature. In so doing, it refers to a world of shared imaginative experience, a vision of pastoralism and harmony. Although Arcadia is an actual region, it was appropriated in the Italian Renaissance as the land from which Virgil's musicians in the Eclogues came and thereafter became the location for a poetic paradise, a literary construct of a past Golden Age. In this place man is regarded as living close to nature but without the harshness it entails.

Like the garden, Arcadia is a construct through which metaphors for life are given a legible context. The concept of Arcadia, which has been defined as the 'landscape of an idea', is one of potential seriousness and complexity, exploring the tension between man's desire for an ideal world and the ineluctable demands of the actual world.[1]

Landscape painting of this sort can be regarded as expressing an awareness of man in nature and a willingness to understand, or even accept the limitations of his power. It is an acknowledgement of alienation, and the insignificance of the spectator or the self.

The Arcadians are therefore regarded as people to whom this revelation is not troubling. Their attitude, more than the reason for discussion, is the moralising component. The Arcadians are not so much torn apart by hysteria or emotional intensity as they are immersed in mellow meditation.

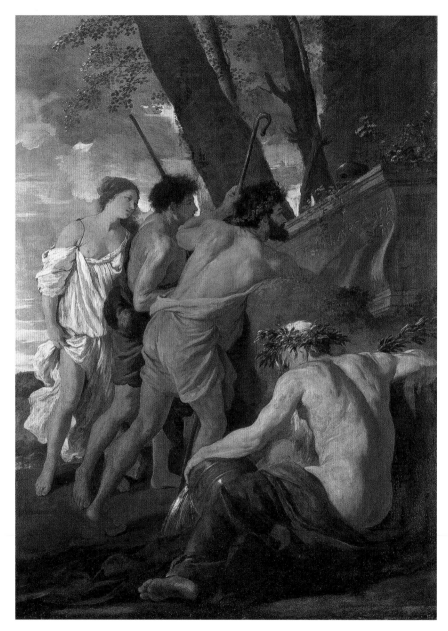

18
Nicholas Poussin, *The Arcadian Shepherds*, c.1628–29
Devonshire Collection, The Trustees of the Chatsworth Settlement

Nicolas Poussin painted two variations on the theme of Arcadia in which the transition from the Baroque predilection for excessive grief was replaced with a classical, melancholic, acceptance.

Poussin's initial version, of about 1627 (fig. 18), retains the strikingly dramatic posture of the human figure typical of Baroque painting. The display of the animated characters parallels the corresponding feeling of insignificance and weakness that arises from the identification with the tomb before them. It has a more overt emphasis on emotion and individualism.

Poussin's later, more widely known, version (fig. 19), painted about a decade later, shows distinctly a development to a more linear, structural composition. The central tomb is turned in parallel to the picture plane, thereby echoing the frame of the painting itself. The shepherds are placed either side, more spread out, and the entire composition is placed in a more open environment. Echoing Greek friezes, the figures are no longer layered one behind the other. Instead they each inhabit their own distinct pictorial space. The background on either side is wider and less densely rendered. The correspondence to the two-dimensionality of a frieze is made even clearer with the female figure who now stands in the classical 'Greek' profile.

Only when viewing the compositional changes is the shift to suggesting a different classical attitude noticeable. The image has been reduced and clarified. The pictorial changes echo the psychological changes in the figures. Notably, in the latter version Poussin has forgone the literal image of death, the skull.

The figures thus no longer have a dramatic encounter with the idea of their own mortality. Instead the central figure, as he reads the inscription, now casts his shadow more overtly over the tomb. In the transition from object to shadow, death is portrayed first as an object inviting action and second as a concept inviting meditation.

The Arcadians are no longer shocked by the sight of the tomb as an unexpected sight, rather they use its appearance as an impetus for discussion and reflection.

This change in attitudes is significant in understanding the idealization of pastoral imagery. This idealization goes so far as to show psychological, as well

as moral, virtue. The Arcadians, in their stoic and measured attitude to death, present an intellectualized mode of approaching an area of discussion which so often is a cause of fear, panic and irrationality. Poussin here demonstrates a very important use of the pastoral, the relationship between urban and rural lifestyle as philosophical allegory.

The noble savage of Arcadia is regarded as man in his primitive state. But is it a state in which he is elevated, not relegated. He is regarded as uncorrupted, virtuous and pure. His moral innocence and clarity of thought is a result of living outside civilization, closer to his instincts, and thus free from the accumulated traditions and triviality of civil society. This gives the Arcadian the ability to articulate thought clearly, away from artificial distractions, and thereby to reflect on the essence and tragedy of all human activity.

No beholder can deny that the world Poussin depicts in the later picture is very far from the real one we inhabit, both aesthetically and morally. The people are beautiful; the light seems warm and luminous but does not dazzle; the great trees are heavy with foliage etc. Poussin's painting shows us the space of art as the ideal space of fiction. There's is a world of clarity and precision, both in aesthetics and in cognition. It presents the Arcadians standing alone against the real world of muddle and clutter and compromise.

19
Detail of Nicolas Poussin, *The Arcadian Shepherds,* or *Et in Arcadia ego* (1636–37)
Musée du Louvre, Paris

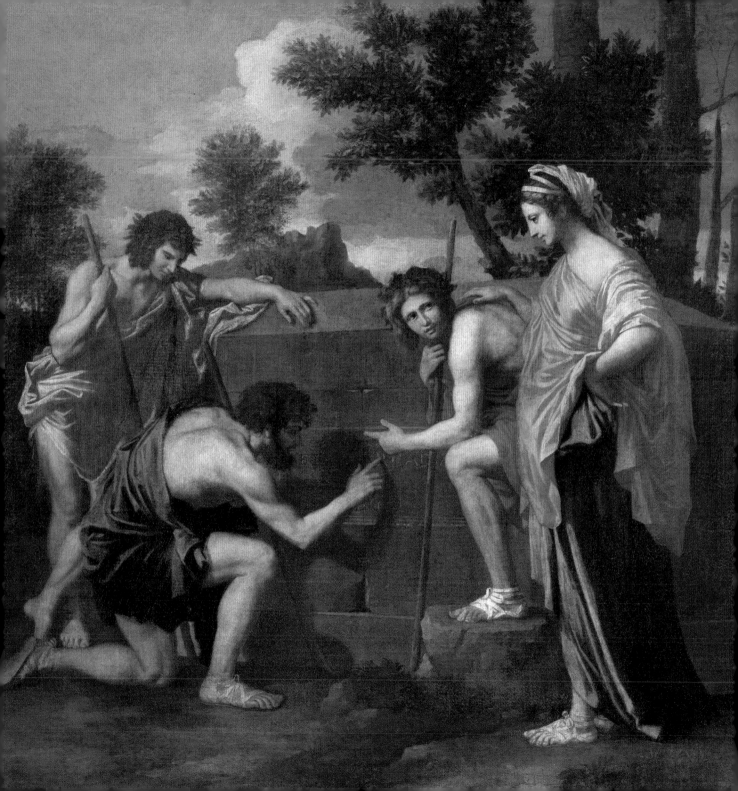

IV
THE GARDENING PRACTICES OF IAN HAMILTON FINLAY

The garden is not an idyllic creation, rather it is in a permanent state of revolution.
Whereas the grove may be cultivated, nature, its governing force, is wild.
Violent action is required – with hoe, spade or axe – to preserve a state of order.
James Campbell

It is apparent that landscape studies demonstrate a belief that the landscape is the product of cultural as well as natural forces. When Carl O. Sauer coined the term 'cultural landscape' in 1925, he signified an inseparable condition in the formation of culture. The cultural landscape he said, "is fashioned from a natural landscape by a cultural group. Culture is the agent, the natural area is the medium, the cultural landscape is the result."[1] Within his definition, the landscape's topography is seen to be a central and critical agent in the production of culture. The landscape is moulded by its people and the people in turn are moulded by the environmental conditions provided by the landscape.

20
Ian Hamilton Finlay, *Corinthian Capital* (1982), Little Sparta

How then should we consider the formation of landscape in the art-form that is gardening? Whereas the arts of painting and sculpture provide a given cultural context, namely that of other paintings and sculptures, the garden's context is ready-made, it is that of nature. One cannot produce a garden design which does not consider in some regard a sense of unity between man and the natural environment.

All gardens achieve this to a notable extent as by its very condition the garden implies a relationship between man and nature and thus between power and its limitations. Nowhere is this sensitivity to the garden's context more apparent than in the gardens created by Ian Hamilton Finlay. His statement, "... as it is possible to transform a hillside into a garden, so it is possible to transform the world", reinforces this interpretation of power.[2]

By his own description, Finlay remained, throughout his life, first and foremost a poet. In the mid 1960s, he was a prominent figure in the international movement of concrete poetry, and notable for his adoption of the 'one-word poem', a mode of inscription which puts one in mind of examples of grammar and composition found in the classical tradition. Finlay was to solidify this parallel further in his later career with his practice of inscribing his poems into stone and marble.

His practice diversified in his later life, however; his grounding as a poet provided him with the capability to give body and thus urgency to an array of ideas, perceptions and feelings.

For Finlay, poetry's greatest tool for snaring and embodying thoughts was, above all, metaphor. In every foray of his work, irrespective of the medium, two or more seemingly incongruous terms are placed in direct relation to each other. These terms, in turn, can only be encompassed metaphorically, conceptually, and, through their enforced collision in thought, each is brought radically to redefine and alter the other.

Concrete poetry is the essence of this practice, whereby both textual and visual modes of notation force the reader constantly to oscillate between reading and viewing. These two methods of observing the object redefine each others'

contexts and thus one finds oneself simultaneously *reading* an image and *seeing* a word. Like the garden then, the inscription is too a place of order inhabited by paradox.

Finlay is perhaps better known today as a gardener-artist and as the creator of Little Sparta, a garden, forty years in the making, set in the windswept Pentland Hills of southern Scotland. This garden in itself could be regarded as a poetic inscription on the landscape, an epitome and summation of Finlay's practice.

Finlay's garden of Little Sparta invokes the neoclassical garden in the English manner. The prime example of this would of course be the gardens at Stowe. At every turn the viewer finds Little Sparta also to be a garden littered with tablets, benches, bridges, planters, column bases and capitals, each intended to elicit poetic and philosophical thought. Finlay's garden, in this sense, should be considered as the accumulated evidence of thought.

Reading the garden as a total work of art, its use of metaphor is rather striking. As a neoclassical garden, saturated with ideologies, yet isolated like an idyll on a barren hillside, it could be read as a sustained meditation on the entangled relationship between culture and nature. It may be considered not only as a bastion against the turbulent and bleak environmental conditions of the Pentland Hills, but also as the unlikely survival of classical philosophy within a society predisposed to Romantic tendencies.

The garden's original name was Stonypath, which Ian along with his then wife, Sue Finlay, began work on in the autumn of 1966. The pair had inherited the old farmhouse and its adjoining land from Sue's parents, and in their first few years of residency set about making the rough, wild and isolated spot into a liveable environment. The scrubland was cut away from its roots and the wild grass replaced with carefully planted trees and flower beds. Enormous ditches were dug by hand to make a lochan and several ponds which were irrigated by the nearby moorland and stream.

The Finlays' struggle against the natural elements of the moorland was not without casualties. Sue recalls that owing to her immaturity as a gardener the many trees which were planted in the early days of Stonypath died in the cold

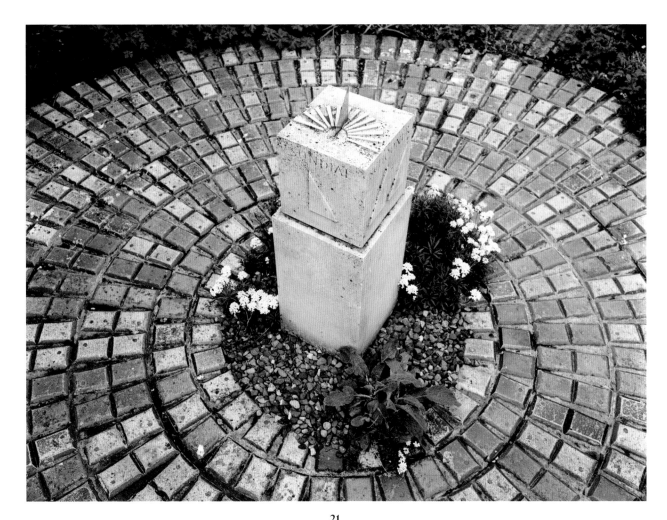

21
Ian Hamilton Finlay with Michael Harvey, Sundial (c.1973), Little Sparta

weather and wind. However, over the next decade Stonypath began to solidify its permanence within the landscape as the Finlay's capabilities increased and the sheltering trees grew in.

Yet, although the vitality and robustness of the garden heralded a victory over the surrounding area, Finlay was soon to encounter more battles further afield.

The strategic and polemical potential of the garden was brought home to Finlay through his reading of Maynard Mack's publication *The Garden and The City* of 1969. Through a focus on Alexander Pope's villa and garden in Twickenham the book put forward an idea that the garden was a place from which the poet could assert his social and political views.

In 1978 Strathclyde Regional Council unilaterally withdrew the rateable relief on what they referred to as the 'Stonypath Gallery' on the grounds that relief was only available to organizations and that the 'Gallery' did not qualify as a religious building, nor did it have an Arts Council Grant. To cement his opposition in this case, Finlay awarded a new title to the garden, which was now renamed under the declarative title of Little Sparta.

Stonypath's new battle-ready name was a reference to the nearby capital of Edinburgh, commonly referred to as the 'Athens of the North'. Between 431 and 404 BC, during the Peloponnesian War, Sparta was regarded as the principal enemy of Athens, and ultimately emerged victorious. Sparta was unique in ancient Greece for its uncompromising social system and constitution, which completely focused on military training, a rigorous aesthetic and excellence.

The confrontation between Little Sparta and the Strathclyde Region reached its peak on 4 February 1983, with the 'First Battle of Little Sparta' of the Little Spartan Wars. The 'battle', which embodied a mingled spirit of wit, rhetoric, moral offence and defiance, concerned the seizure of several works of art in Finlay's possession. Like the Sparta before it it too initially emerged victorious after Finlay and his supporters, the Saint Just Vigilantes, defended the stronghold against the attempts made to seize the works. Two weeks later, however, the council officers returned and the works were taken away.

As Finlay's prominence as an artist grew internationally his work and practice as a gardener developed in complexity. This was in no small part to his growing familiarity with Greek philosophy and literature, as well as with the history of the French Revolution.

As much as Little Sparta can be thought of as a defence against its surrounding elements, it nevertheless bristles with real and disconcerting images of warfare, revolution and violence. Finlay saw in these images forms of sublimity and terror, relevant to our own age and to the essence of the garden. The icons of a classical past, of gardening practices, and of modes of warfare are used simultaneously. The tank tracks which lead off into the undergrowth are equally suggestive of fallen fluted columns or else of tractors and machinery used to mould the landscape. It is as if the explosives used in modern warfare, which may be seen literally to alter the landscape, have been used as a planter to seed trees and dig ponds.

In 1972 a 'Nuclear Sail' was installed on the banks of the lochan to enforce its full armament possibilities. The emergence of the sail from the soil is suggestive of both an abstruse hidden meaning and of something compelling laying undiscovered under the surface.

Yet it may suggest another reading also, that in fact what we see is not part of a hidden other, rather the sail is implying that the garden itself is the submarine. One may even stretch further and regard the moorland, on top of which the garden sits, to be the true hidden power which continually threatens the temporary idyll of the garden with its ultimately destructive powers of weather, erosion and time. In this manner we may regard the apocalyptic shadow cast by our own real-world nuclear capabilities in the same way as the surrounding moorland with reference to Little Sparta, which it has the capability to return to its previous incarnation of scrubland.

As Finlay has stated on this topic, "To use the warship is not to say I wish there to be giant navies. It is to allegorize or present the fact that power exists."[3]

In the manner of Little Sparta, this power may be manifest both as the power of ideas and as the real-world omnipotence of entropy.

A work from 1969 sits on the edge of the Temple Pool and announces of the pond:

HIC IACET
PARVULUM
QUODDAM
EX AQUA
LONGIORE
EXCERPTUM
[Here lies a tiny excerpt from a longer water.]

The reader is thus invited to meditate upon the pool as a fragment of a larger world, just as the garden in which is sits may be seen as a fragment of the landscape. The 'longer water' from which this 'tiny excerpt' has been taken itself could be regarded as the nearby natural spring which runs down from the surrounding Pentland hills and sustains the ponds. So too the excerpt could be regarded as a word taken from a larger sentence or poem.

In this sense, then, the garden's parallels with Finlay's initial work as a single-word poet seem apt. They also suggests that we must seek to understand the garden not only in itself but through its many relational contexts.

Throughout his life Finlay familiarized himself with classical philosophy, the history of garden design and its potential as a site for poetic contradiction. Thus, the successive passages found in his garden which imply a 'rearmament', in many senses of the term, constitute a sustained campaign launched from the silo of Little Sparta out into the wider world.

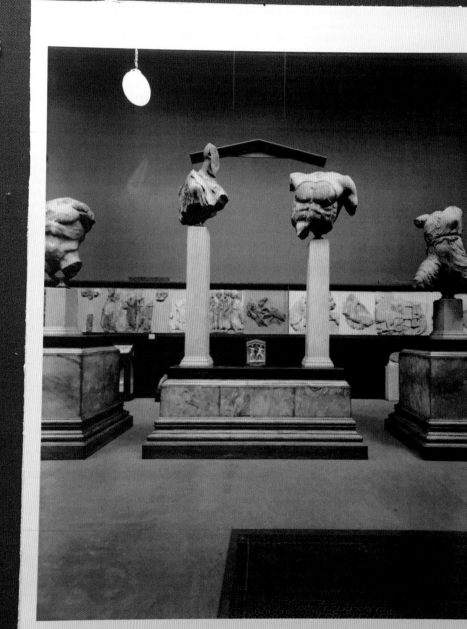

V

REALISM
CONCEPTUALISM
CLASSICISM

The contemporaries and rivals of Zeuxis were Timanthes, Androcydes, Eupompus, Parrhasius. This last, it is recorded, entered into a competition with Zeuxis. Zeuxis produced a picture of grapes so dextrously represented that birds began to fly down to eat from the painted vine. Whereupon Parrhasius designed so life-like a picture of a curtain that Zeuxis, proud of the verdict of the birds, requested that the curtain should now be drawn back and the picture displayed. When he realised his mistake, with a modesty that did him honour, he yielded up the palm, saying that whereas he had managed to deceive only birds, Parrhasius had deceived an artist.

Pliny, *Historia Naturalis*, 35.64–66

22
The Elgin Marbles in the British Museum (c.1920)

In the history of art, and philosophy for that matter, there is no single, agreed definition of 'realism'. Yet nearly every work made in the Western canon relies on some realist claim – a claim to be able to articulate the real world no matter how counterintuitive such claims may seem. In fact, it could be argued that the criterion for realism in art relies precisely on this counterintuitive claim, and that the direction taken by realism in the Western classical tradition is a direction towards greater illusionism and deception.

Realism is an issue not only for art; it is a major political, philosophical and practical issue that must be handled and explained as such – as a matter of general human interest.

It might equally be claimed that, at least in its implications, realism is perpetually at issue. Realism in this inclusive sense can briefly be defined as the assumption that it is possible, through the act of representation, to provide cognitive as well as imaginative access to a material reality that is nevertheless independent of it.

To investigate realism in art is immediately to enter into philosophical territory, into questions of ontology and epistemology; of what exists in the world and what can be known about it.

Descartes's celebrated, but by now clichéd, phrase *Cogito ergo sum* is more than an affirmation of the self-conscious, reasoning, human subject. It is the assertion of a sufficient and necessary link between thought and the material world. More specifically, it is the assertion of a conformity between human thought and a reality which is to be mediated in some way by perception and, more dangerously, by assumption.

In so far as realism pretends to offer us an unproblematic representation, it is in fact the most deceptive form of representation, reproducing its assumptions through the audience's unexamined response to an apparently natural image or text. In replicating empirical reality as exactly as possible it dreams of attaining a complete correspondence to it, and is inevitably doomed to fail.

23
The Elgin Marbles in the British Museum (c.1914)

*The enduring relevance of Pliny's anecdote is remarkable:
indeed, unless art history finds the strength to modify itself
as a discipline, the anecdote will continue to sum up the
essence of working assumptions still largely unquestioned.*

Norman Bryson, *Vision and Painting* (1983), p. 1

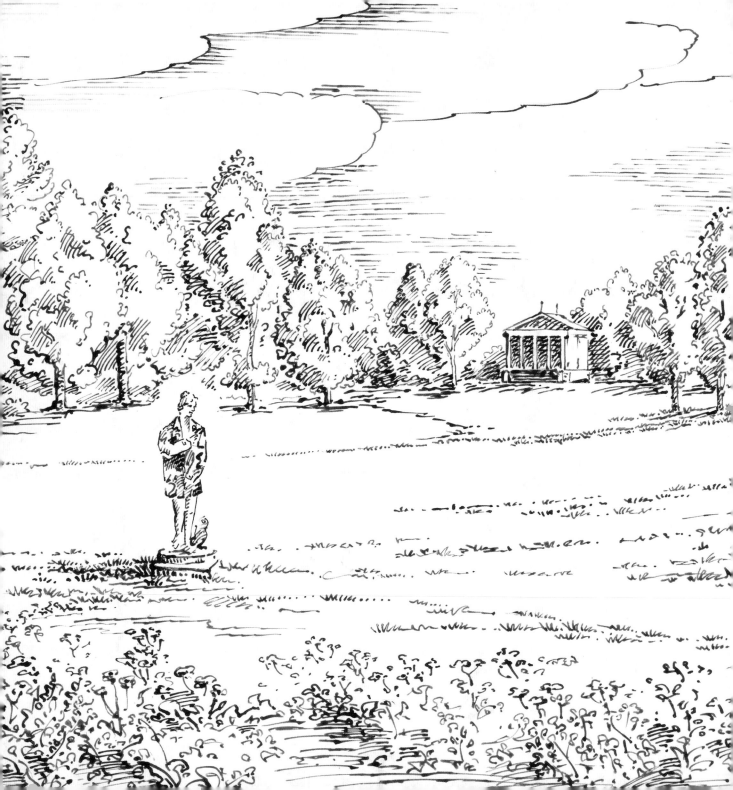

THREE MORE PROPOSALS

GARY HINCKS

In 1985 Ian Hamilton Finlay in collaboration with the illustrator Gary Hincks embarked on a series of six proposals. This series of drawings, entitled *Six Proposals for the Improvement of Stockwood Park Nurseries in the Borough of Luton*, showed ideas for work by Finlay set within the pastoral landscapes of Claude Lorrain's *Liber Veritatis*.

Three More Proposals, commissioned by Joseph Black for this publication and again illustrated by Hincks, shows larger works and installations which Finlay made throughout his life set at intervals through Stowe Gardens. The first shows his 1977 *Lyre* set between the paths of Vice and Virtue, and along the line of sight created by the House and the Corinthian Arch. The second shows his *View to a Temple* of 1987 flowing down the Elysian Fields, rending the line of sight created by the two temples visible beneath the hanging blades. Finally, *The Aphrodite of the Pastoral* of 1993 is placed standing in the Grecian Valley responding to the distant Temple of Concord and Victory and its statues representing painting and sculpture.

With this new series of drawings Black is asking us to reflect on the nature of artistic response and collaboration as fundamental to the production of a garden design. In doing so he shows us that artistic production exists within an intricate and complex web of relations and influences, contemporary, historical and experiential. In this way the garden can be read as a reflection of the society from which it is born and in which it continues to exist.

LYRE
1977

PROPOSAL. *An Oerlikon Gun inscribed as a vision of Apollo placed on the intersection between the paths of Vice and Virtue. The weapon is placed on the line of sight through the House to face the Corinthian Arch in the distance.* Lyre *was first exhibited at the Silver Jubilee Exhibition of Sculpture in Battersea Park, London, June–September 1977.*

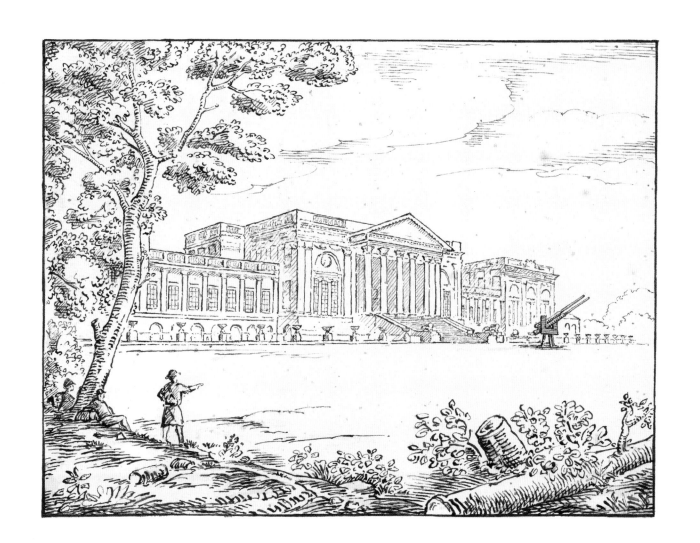

A VIEW TO THE TEMPLE
1987

PROPOSAL. *Four over-sized guillotines are placed, axially arranged, down the Elysian Fields. They are placed between the two temples at the top and bottom of the 'fields'. The bronze 'droppers' of the execution instrument bear inscriptions from French Revolutionaries on the relationship of the moral idea to its violent enforcement.* A View to the Temple *was first shown in 1987 at Documenta 8 in Kassel, Germany.*

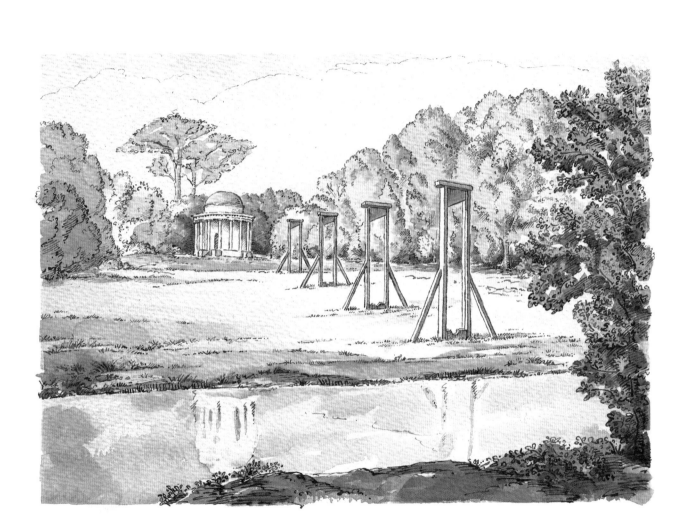

APHRODITE OF THE PASTORAL
1993

PROPOSAL. *A* Venus de' Medici, *made from plaster, is placed to stand in the open centre of the Grecian Valley. She wears a US Army camouflage jacket and is framed by the Temple of Concord and Victory in the far distance. Aphrodite of the Pastoral is one of many works Finlay made throughout his career using a* Venus de' Medici.

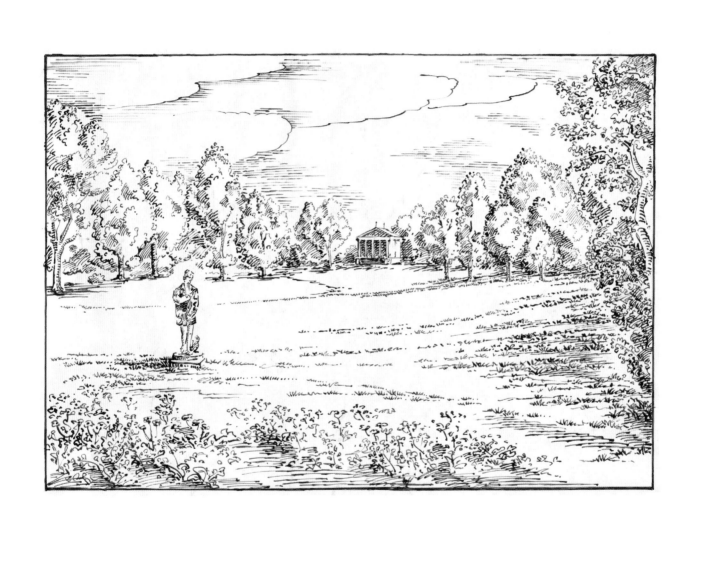

PERHAPS, A STOWE

JOHN DIXON HUNT

A conventional wisdom has held that picturesque gardens derived from paintings, sometimes that they were even based on specific paintings. Yet the closest relationship between the two is that eighteenth-century garden makers and visitors may have transferred their familiarity with paintings to a way of understanding the very different world of gardens. They saw in the former a range of buildings and statues, where figures acted out a moment of historical or personal drama, and they found there a poetry – a way of talking about what they saw in a painted landscape – that could be useful when wandering through gardens. At the best, it was not a model, but a useful analogue that nevertheless changed during the eighteenth century.

Three differences were essential to the art of landscaping. The garden itself changed through the hours, the seasons and the years, so was never static. And visitors moved through gardens. Nor did a designed landscape lend itself to one particular theme or topic, like a painting, which enjoyed either a title or a clear presentation of an event. Gardens were an open adventure. There were triggers and prompts built into them, to be sure; yet each visitor also arrived with a multitude of associations that they tended to test against what they encountered.

24
The Elysian Fields

Stowe was contrived as a series of scenes, through which one progressed. Observing a temple, hermitage or column suggested some meaningful idea; but then it afforded a place from which to view other parts of the gardens. It was a combination of movement of feet and movement of mind, mingling visual pleasures with some attempt to grasp the conceptual significance of what they confronted. It was what many eighteenth-century visitors, familiar with painted landscapes, relied upon as a familiar mode of response in gardens.

There are also moments when visitors might hold several items in sight as in mind – when the Temple of Ancient Virtue can be held in the same frame as the Temple of British Worthies across the River Styx (fig. 24). The temples are striking structures and, if we know their names (which do not appear on them), they provide clues as to what we can discover in them and by comparing their shapes and messages. As we literally move between them, our 'focus' is continually, if subtly, shifting; we change our understanding of what we see.

So too when we cross open ground towards James Gibbs's extraordinary temple in the fields (see fig. 16) – triangular in shape, battlemented, with pointed arches and brown stones (Walpole's "rust of the barons' wars") – there is the perplexing question of what to call it (and therefore how best to grasp what it signifies): is it the Temple of Liberty? Or the Gothick Temple? And why do those particular forms and colours of the stone steer us to notions of liberty or the Gothick? What Gibbs's temple is *not* is an emblem of the Trinity (Father, Son and Holy Ghost), like the similar triangular structure created by the Catholic Sir Thomas Tresham at Ruston in Northamptonshire it the late sixteenth century; there it was clearly an expression of Faith, with its mottoes, emblems and Christographic dates and mottoes, whereas this Stowe temple, as others, shapes some responses, but not too many and not too precisely. Readings of landscape are now less determined by what is there than by how visitors choose to respond.

We can and should discuss the historical culture out of which Stowe emerged in the major years of its creation; we can see more in Gibbs's temple by asking what traditions of liberty and Gothicism in England could mean in the eighteenth century. But we also, as this exhibition makes clear, need to extend

that discussion to welcome Stowe into a narrative of how we respond to great landscape creations that still survive so potently. Beyond a design history, then, we want what to invoke what I have called the "afterlife of gardens".

William Kent, and perhaps later Capability Brown, are useful here. In Kent's day paintings were images into which we could "walk" – equivalent to what Diderot would famously provide in his *Discours*: within a painted scenery its visitor could speculate on the many items that he might encounter in his imaginary promenade. Kent was a theatre designer as well as a painter, and theatres are places where what is performed is received by a specific audience – there is an 'exchange' there, as much as in front of any painting. We do not always know how an audience will react (another designer at Stowe, Vanbrugh, would have been aware of that too), just as we may be uncertain what a painting means. The famous painting by Poussin of a man being strangled by a serpent is conventionally entitled *Landscape with a man strangled by a snake*, but an original viewer thought it was *Three Degrees of Terror* – different people having different responses to this attack (those of the man himself, and two others, a man and a woman, who either observe that death or only watch people responding to it without themselves seeing it).

Brown, who followed Kent at Stowe, brought some different assumptions about how to make and respond to landscape. While it sometimes pleases people to see Brown as a simple gardener type, he was a thoughtful if not learned man, able in one of his rare remarks to acknowledge the role of the "Poet and the Painter" in creating landscapes. Nor was he a mindless purveyor of untouched nature. He was concerned with and eloquent about the performance of two things, celebrating the forms of natural things and finding ways to make visitors respond to that. In another of his famous remarks, he explained his designs as constructed like a paragraph, with pauses, commas, colons, a parenthesis or a full stop; in that way he helped visitors respond to a negotiation of the scenery he designed, to the way he *manipulated* the forms of the natural world.

That was exactly Ian Hamilton Finlay's shrewd view of Brown: "Brown made lawn into Lawn, water into Water". Utterly simply, utterly transformative. In

short, he elevated, epitomized, the natural forms of the landscape into a more striking and visual sense of their own perfections. Finlay's own response to making landscape was, so to speak, a collaboration between Kent and Brown. He expected people who walked through his landscapes to seize the triggers and prompts that he inserted, notably through inscriptions. These may direct attention, but we are not inherently dependent upon them for understanding his concepts. Yet his landscapes are also replete with a rich and careful manipulation of natural things: his own ponds became Ponds, his own pathways Paths, and styles or stiles became what he termed "an escalation of the footpath".

This is not to say that Stowe has never been the object of depictions. But that does not mean that painters drew its gardens because they saw them as emanating from paintings. They wished rather to provide English landscapes, uniquely apt (as they saw it) for patriotic sceneries, with a lustre that another art form could contrive. Jacques Rigaud's paintings from the 1730s celebrated the garden's busy visitation and how the temples provided a setting for that depicted moment (the family motto being, of course, *Templa Quam Dilecta* – how beautiful are the temples).

Sometimes these representations were simple vignettes, as in Stowe's many guide books, to conduct visitors in their identification of the various temples. Then in the early 1800s came two albums of watercolours of Stowe by John Claude (sic!) Nattes, now held in the Buckingham County Museum. Each artist had a specific purpose in mind, a specific audience to please: Rigaud's attention to the French notion of the promenade bestowed a distinctly Continental aura upon Stowe; Nattes's was inclined to scenes that catered to a freshly minted picturesque, also noting a different kind of visitor and ensuring a much more catholic appreciation of the different elements of the Stowe landscape.

If Stowe encouraged responses to the phrase *ut pictura poesis*, much bandied about during the eighteenth century, these were as much concerned with a *poesis*, that is to say a making, rather than with poetry or verses *per se*; not a specific picture, but a conception of what the scenery and its buildings could mean to its many visitors. This need to respond, to understand how a landscape

was made (poesis) and what its making could mean, continues today, and this exhibition explores that continuing challenge.

When Nattes drew the Grecian Valley, with its cluster of pastoral sheep, but without the Temple of Concord and Victory at its head, he hints at, without emphasizing, the neoclassical and pastoral character of this later addition to the estate. When Gary Hincks in this exhibition redraws parts of Stowe to insert into them emblems from Finlay, he is asking that we reflect about a specific place and a collocation of ideas that can cluster now around that site. So when we return into the gardens and revisit the Grecian Valley or the Elysian Fields, it may unleash associations that range from classical Greece and Rome to Baroque temples, from ancient music to contemporary concrete poetry, from eighteenth-century to modern gardens.

As Pope proudly noted in 1731, nature here shall grow, with the help of designers, "a work to wonder at, perhaps a Stowe".

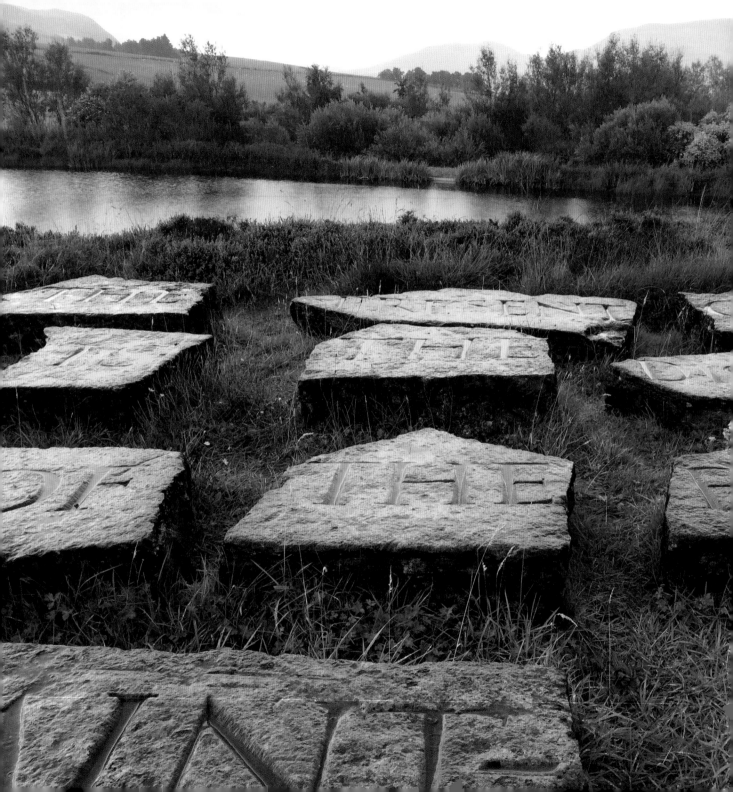

INTERVIEW ON THE FIRST BATTLE OF LITTLE SPARTA

IAN HAMILTON FINLAY

IAN HAMILTON FINLAY: The point at issue was the garden temple and when the garden was being made the building that is now the garden temple was left over, it was a ruined cow byre. When people started to come to see the garden it became necessary to have a space that was a bit separate from the domestic space. So the building was repaired and at first I thought of it as a gallery, but gradually I became aware of something that I find very difficult to formulate but, to put it crudely – of a kind of crisis in Western culture. And it seemed to me, and still seems to me, that whereas, in the past, art had overlapped, in an undefined way, with religion and certainly with scenes of spiritual activity, that art now in our time had become more and more secularized and it didn't overlap in any way with religion or with the vision of the spirit but rather had become an aspect of tourism.

It seemed to me that really, just as Robespierre saw the religious issue as central to the French Revolution, so it came to seem to me that the religious issue was central to this time and that the crisis in the West is what I call the death of reverence, or the end of piety – just a complete secularization of everything. Which seems to me to be leading to absolute disaster.

25
Ian Hamilton Finlay with Nicholas Sloan,
The Present Order is the Disorder of the Future – Saint Just (1983), Little Sparta

At this point I got a new understanding of the garden and I saw the garden as essentially a spiritual territory or an ideological territory. Because I wanted it to be understood what I was doing I changed the building from being a gallery to a garden temple. The difference was that, if you leave out that the fact that it was a dry place that people could go, as a gallery the building existed in order to exhibit the works of art. Whereas, as a temple, the works of art exist in the building as part of the building to determine the nature of the building: that's the difference.

In the laws which govern Strathclyde Region any building which is not only held by an individual, and is used wholly or mainly for religious purposes, is exempt from tax. So I considered that therefore the building was exempt from tax.

They at first argued that the building couldn't be categorized as a 'garden temple' because the words didn't exist in the regions computer. So I said well, the words occur in any reputable history of Western gardening. As a citizen of a country which is part of Western culture I shouldn't need the right to use the words and to have them taken seriously, and there was a long dispute over that.

After five years or something, it was conceded that the building could be categorized as a garden temple. But then there arose the second question: is the building religious or not?

I maintained that if one understands as I do the French Revolution, or certainly the Robespierreian, David etc., part of it to be religious then certainly that building is religious. As long as it is not granted tax exemption then what they are really saying is that you can pretend it's religious, that artists are allowed to pretend, but what I'm saying is I'm not pretending, nor is my art pretending this is a building with religious being. Because there was money at issue they were held to the question, and I was also held to the question, but I wanted to be held to the question, because it seems to me the crucial question facing Western culture.

There was this famous First Battle of Little Sparta [in] which the sheriff officer came and arrested certain works. He actually insisted on arresting these dryad figures.

INTERVIEWER: When you say arrested what do you mean?

IHF: There is a process that they go through: they put a notice. What they do, the classical way of resolving it in the region, was to hold what they call a warrant sale. That is, that they would auction off a certain part of your property to cover the money that they supposed to be due

They put a notice beside the objects they were arresting saying that these were now the property of the Queen and can't be moved. He insisted, a very strange man, very tall, very handsome, he really looked like somebody out of the French Revolution, very immaculately dressed, actually looked very like Clint Eastwood. Later there was an American filmmaker called Alan Pakula and they wanted to make a film about our thing but in the end they didn't do it. But at one time they were very serious about making a full-length feature film about it and I said that the sheriff officer should be played by Clint Eastwood. I told the sheriff officer this and he was absolutely delighted. He felt that at last somebody had recognized his true identity.

Anyway he put this notice and he insisted on arresting these three dryad figures, and I said to him do you not think that it would be better to arrest something else because I saw what would happen, the press would ask what he had arrested and I would say three dryads. So there was obviously something quite nice in a way but maybe not so nice for him. So, no, no, he insisted. I think actually the fact is that he coveted these figures or his wife coveted them or something. Anyway, he arrested these figures and then the date was set [on] which he would come back and auction them off.

I was able to get all my supporters here, the Saint Just Vigilantes. They have Checkpoint Charlie in Berlin and the region always calls the sheriff officer – to make him sound homely – Sandy.

So we make Checkpoint Sandy which is this middle gate and we had a striped pole and everything. Then we had a full-sized mock-up of the German Panzer Mark IV dug into the hillside covering the gate. I had a hideout in the hayloft where you could see everything that was happening, and then we had minefields all around.

For some reason this attracted the attention of the nation. And on the day, which dawned like Stalingrad or something with thin powdery snow and an icy wind and the most forbidding-looking mountains, three separate television companies and eighty reporters turned up. We had also a Red Cross station with the Red Cross flag flying and we had the Roman flag flying.

I knew there were certain rules that had to be observed and this allowed one to make a kind of strategy. One of the rules was that obviously he would try to get into the garden temple but I had it all barricaded from the inside. I also knew that, before he would break in, he would ask me formally to let him in, so, as long as I remained hidden, he was in a bit of a quandary.

I made all the television people park outside Checkpoint Sandy and because the field was frozen it was perfectly possible to do that. He had, naturally being him, fixed the time [as] noon for his arrival – high noon I suppose he thought of it as.

He arrived six minutes late and he was stopped by the barrier. My plan was that because there was a barrier he would be bound to drive through because he would feel impeded. So he got out the car and said to the Saint Just Vigilantes at the gate, 'Do you know who I am?' And they said, 'Well, we hope you're the sheriff officer', whereupon he lifted up the gate and as the paint was very fresh he immediately got covered in this red and white paint.

Anyway, he drove through and the neighbouring farmer had very sportingly agreed to take part and he was waiting in the farmyard on his tractor with the engine running.

Oh, I forgot to say, leading from Checkpoint Sandy at the other gate we had a string. Did you every make, when you were wee, telephones that were tin cans and string? Well, we had the longest one there ever was in the world leading right up to here. So word was sent up, the sheriff officer has passed through the barrier in his car.

I immediately sent word that the farmer was to come and he drove round and just beyond the middle gate there is a little bridge across a stream. So he drove the tractor through the barrier and on to the bridge and took off a wheel.

The sheriff officer, now unknown to himself, so far was trapped in Little Sparta – rather than being trapped outside as he had feared. Anyway, he then set off to look for me, once he discovered that the temple was barricaded, and of course I was hidden up in the hay and couldn't be found, but everywhere he went he was followed by these three tele crews and these eighty reporters. It was all very dramatic.

After a certain time when he had searched through the house and all the rooms and so on and so on, then he decided he knew I must be hidden in the garden temple; which of course I wasn't, I was in the hay. He set off to get the police because he was now going to break in.

I suppose he was worried that if he broke in the Vigilantes would set upon him or something. So he set off to get the police but of course now discovered his car was trapped in Little Sparta and the nearest phone was six miles away. So he set off, watched by everybody, on foot to walk down the road.

Now it was very dramatic because we didn't know, you see, would he come back with just local police or would he come back with three hundred armed police, or six hundred armed police, or what? Anything was possible in Strathclyde Region which was quite a tough-going place. So everyone waited and we had Saint Just Vigilante sentries on the hillside and we had a chap on the roof with a bell. The thing was, he was to toll the bell when the sheriff officer with the police came back. So after about an hour and a half the bell tolled and I was now safely hidden up in the hay again along with other Vigilantes.

It turned out that one of the reporters had told him where I was so he came straight up and found me and the Vigilantes hidden in the hay. We all came out with our hands up, which looked very good in the newspapers.

Anyway, the reporters then demanded that I make a speech. So as I was, and remain of the opinion, that the whole thing was illegal because the building is exempt from paying tax, that it was wrong for them to get a warden and whatever, I made a speech to the eighty reporters who gathered around me, demanding that the United Nations send in paratroops immediately to restore order in Strathclyde Region.

But while I was making this speech the sheriff officer, who was no fool, earlier in the morning in the course of looking for me had walked a number of times around the garden temple, and there is a little narrow window in the back which hadn't been barricaded because it didn't occur to me, or anybody else, he could possible get in it. But he had one of those burglars tools called a jemmy and he cleverly opened this window and very athletically inserted himself in it and appeared inside the temple.

Immediately there was this great cry went up, 'He's in, he's in, he's in!' So my speech had to be interrupted as everybody rushed to look through the windows at him.

He did this extraordinary thing. When the temple is tidy, as it usually is, we ask people to put on slippers partly to demarcate it as a special space and partly because the whole place is muddy. Anyway, the first thing he did when he got in was to put on the slippers – which was a quite wonderful gesture. Then he proceeded to look for the dryads.

Unknown to him we had, very daringly, because no one has ever touched and arrested things before, we had removed the dryads two days before and hidden them in the trees where we felt they would be at home, you see. So he couldn't find the dryads but he searched all through and eventually he gave up and he came out of the building. And now the strange thing was that I had always said that if he broke into polly's temple [Apollo's Temple; fig. 23] that an arrow would get him, but this was just pure mythology.

But lo and behold he came out holding his hand with a tiny little wound on the back of his hand just the size of an arrow head, and was pouring blood. At this point everyone thought that at this point he would announce that I would be arrested and all the Vigilantes would be arrested and would be taken off by the police.

I forgot to say, that he brought police back with him but just local ones not armed, and we would be taken off to prison. Because to move objects which had been arrested by the Queen was just like the most terrible offence that can be imagined!

Anyway, to everybody's amazement instead of announcing, telling the police to arrest me and so on, he said, 'I'm finished for today'.

Then he turned to my wife and indicated his wounded hand and said could he be allowed to wash. So people parted and made this little way for him.

She led him in and took him to the bathroom and washed his wound and bandaged it. I had phoned up and told the farmer to put the wheel back on and then I said to him, 'You're free to go, the bridge is not blocked any longer', and he went off and that was it.

It was really quite an amazing day, just quite amazing, and all the Vigilantes who'd never, like me, paused the police and so on before were terribly thrilled and said, 'Let's have another battle right away!' But I said no, we can never have this battle again. It's not possible. But we can have other battles that will be planned in a different way, but not this one ever again. It would not be so easy again either, because he had really learnt a terrible lesson and the region had learnt a terrible lesson.

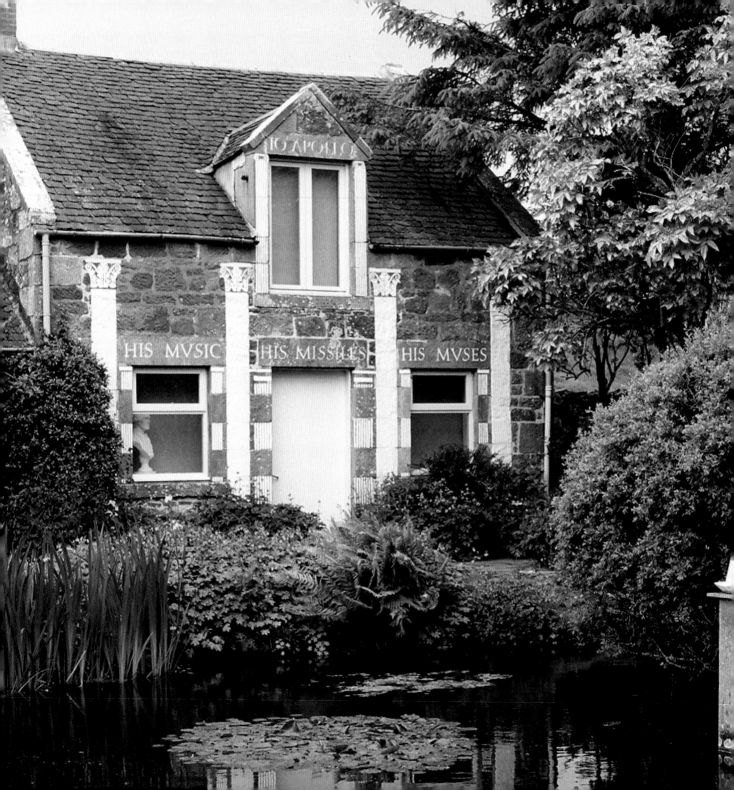

TWO SHORT ESSAYS

JOHN STATHATOS

PIETY AND IMPIETY: THE LITTLE SPARTAN WARS

It seems increasingly likely that, once the millennial dust has settled, Ian Hamilton Finlay's garden at Stonypath will come to be recognized as one of the late twentieth century's most important artistic achievements. First hacked out of a barren Lanarkshire hillside by Finlay and his wife Sue more than twenty years ago [autumn 1966], the garden consists of a complex and ever expanding series of plantings, major landscape interventions, a succession of cunningly devised vistas and numerous three-dimensional artworks by Finlay and his collaborators. At the heart of Little Sparta lies the Garden Temple (fig. 23), around which building – its nature, identity and legal and cultural status – have raged the Little Spartan Wars. This is a conflict which has baffled many otherwise well-disposed observers, some of whom tend to treat it as an irrelevance, even at times an embarrassment. Others probably feel that it has dragged on long enough, that the point was made years ago, and that regularization of the situation is now well overdue. Such an attitude, however, misinterprets an essential

26
Ian Hamilton Finlay with Nicholas Sloan, The Temple of Apollo (1982), Little Sparta

dimension of Finlay's principal creation: far from representing a rhetorical flourish, an entertaining side-show or a bloody-minded aberration, the Little Spartan Wars are an integral part of the Stonypath project. Ostensibly mired in abstruse legalistic arguments over local taxation, and superficially seen as yet another example of that ever popular British spectator sport pitting plucky but eccentric Davids against the Goliaths of bureaucracy, they are in reality about piety and impiety and the meaning of these terms, if any, in the contemporary cultural arena.

For Finlay, the principal crisis of Western culture resides in the death of piety – in other words, in the commodification not only of culture but of everything it ever stood for. Evidence of impiety may be found in the bureaucratic relegation of the arts under the rubric of 'recreation and leisure', in the way tradition is increasingly treated as external and, in the most literal sense, eccentric, and above all, perhaps, in the fact that public debate around such questions is no longer regarded as laudable or even permissible.

For Finlay, the ongoing process of secularization must be actively resisted, 'the garden consciously challenging the surrounding culture'.[1] By this token, the artist's challenge to the bureaucrats of Strathclyde Region is not a piece of opportunistic street theatre but a reflection, albeit a partly symbolic one, of the principles espoused by the French Revolutionaries commemorated in the garden's monuments and inscriptions.

The origins of the Little Spartan Wars are as undramatic and even banal as those of any other conflict. In October 1975, Sue Finlay applied for and received a 50% discretionary relief on the rateable value (property tax) relating to what was at the time described by Strathclyde Regional Council (SRC) as Stonypath Gallery, a converted barn in which Finlay displayed concrete poems and other collaborations published by the Wild Hawthorn Press. The relief was unilaterally withdrawn in December 1978 by the Region's Assistant Director of Finance on the grounds that 'such relief may not be granted to individuals, only to organizations';[2] two months later, a further communication added that the decision had been taken 'on the basis of the information provided which

indicated that the premises were used to a large extent to house and display the work of an individual, and because access was by way of appointment thereby restricting public benefit'.[3]

Finlay's response was matter-of-fact, refuting any suggestion that the Little Spartan conflict was deliberately provoked by him; this is clearly the retort of a man prepared to argue his case with bureaucracy, but oblivious of the fact that he is firing the opening salvo of a war now almost twenty years old:

Thank you for your letter in respect of our gallery discretionary rates relief. I would certainly like to appeal, and will be glad if you will tell me how I can do so. In respect of the 'terms of the scheme operated and approved by the Regional Council', I would assume – over-optimistically, as it may be – that 'terms' are to be interpreted in the light of a generous common sense, since our gallery is an aspect of culture and regional authorities, history shows, have not always been to the forefront in that area. I have never assumed any automatic rights to rates relief, but did assume that discussion would be permissible – would even be <u>desired</u> *by the Region. In such discussion as I have had I have been given a number of very different reasons for the withdrawal of the relief – for example,* <u>that if we were a proper gallery we would have an Arts Council grant</u>*, and that* <u>we are not an organization</u>*, and that* <u>the public has restricted access to our gallery and garden</u>*, and* <u>that we might sell something</u>*

The question of public access, is, it seems to me, a crucial one. It is peculiarly dispiriting to have the 'appointment only' stipulation cited as if it were a negative stipulation. It is perfectly clear that all public access to anywhere is to some extent limited. (Try ringing your Rates Dept. in Hamilton, at 6 am, for example). It is a fact that no serious visitor has ever been refused a visit to our gallery and garden, and the stipulation has been practical Thank you. I still hope we may be allowed an actual, serious discussion.[4]

The conflict has been considerably complicated by Finlay's chronic agoraphobia, a condition which makes it impossible for him to leave Stonypath to attend trials or hearings; this factor, however, is balanced by his belief that debate about the nature of the temple and garden is in any case best conducted at Little Sparta itself, where the spell of the *genius loci* can manifest itself. Accordingly, Finlay was unable to attend an initial appeal scheduled for March 1979, proposing instead a meeting in the gallery, or else "a proper phone discussion".[5] In the event, this discussion never took place, and later that year Finlay took the momentous step of re-designating Stonypath Gallery as a Garden Temple:

> *In any case your Rates demand is no longer applicable. We have clarified our position by re-defining our (one-time) gallery as a Temple, on the precedent of the Canova Temple (doubtless familiar to you) at Possagno. I look forward to hearing what the Strathclyde Region Rates Policy on Canova-type Temples presently is, and will of course be glad to welcome any official who cares to come and discuss this matter within temple hours.*[6]

On one level, Finlay is here as whole-heartedly serious as ever; but, on another, the sheer malicious sense of fun with which he lobs this new ball at the Region is unmistakable. The correspondence which ensues is a minor work of art in itself:

> Depute Assessor Hamilton to Assistant Director of Finance, SRC, 22.5.80: *I can think of no other description for the subject at Stonypath, Dunsyre, than 'Art gallery'. It is used for the display of works of art, albeit that Mr. Finlay insists they are poems. Perhaps Mr. Finlay could suggest some tangible description for the subject to you, and I shall alter the description in the Valuation Roll.*

> IHF to Assistant Director of Finance, SRC, 9.6.80: *Thank you for your letter of 27 May. The correct description would be: Canova-type Garden Temple. I enclose the original Rates demand.*

Depute Assessor Hamilton to Assistant Director of Finance, SRC,19.6.80: *It seems that Mr. Hamilton Finlay can suggest no normal description for the above subject and I am, therefore, not prepared to alter the existing Valuation Roll.*

The dispute between Finlay and the various avatars of Strathclyde Regional Council is clearly as much one of language as of legalities, of style no less than substance: reading through these documents, it is immediately apparent that two different languages, two different ways of describing and ordering the world are here locked in conflict. The interlocutors may sometimes understand one another, they may even once in a while display sympathy for each other's position, but they represent essentially irreconcilable ideologies. Finlay's opponents are not brutes, and only rarely fools, but they remain incapable of breaking the administrative mould, that mind-state in which authority does not – cannot – debate, but only decree:

And again: to say that my work is that of an 'individual' is wholly ridiculous. What we have here is the expression, not of a person but of a <u>tradition</u>; actually and allegorically, every work is a collaboration. When Strathclyde quotes one as saying that the works are collaborations, <u>in order</u> to argue that they are the works of an individual, there is nothing to say – no Appeal to be made: they are not acknowledging any idea of exchange or discussion.[7]

By November 1980, Strathclyde lost patience with Finlay and issued the first of a long string of Summary Warrants against him, warrants which it was clear the artist had no intention of complying with – or at least, not unless and until he was granted the opportunity of debating the issue on his own terms. One of the earliest and most concise formulations of Finlay's position regarding the status and nature of the Garden Temple is contained in an application for relief dated September 1981, under the section "details of purposes for which property is used":

This building, correctly designated as a Garden Temple ... is properly part of the Stonypath garden and remains open to visitors throughout the year (even when the garden is dormant).

It is widely recognised as a sanctuary, an integral part of a garden 'quite unlike any other', a 'philosophical garden' (Dr Stephen Bann); the purpose or aim of the temple is the traditional one of celebrating the Muses, and its contents are intimately related to the garden as (prosaically) an object and (ideally) a manifestation of the Western spiritual tradition. It is clear that education, literature, the fine arts, and religion are not separable from this ideal.[8]

In practice, there was little point in appealing to the Western spiritual tradition so far as the administrative machinery was concerned; Strathclyde's computer did not recognize the term 'garden temple', the Valuation & Rating (Scotland) Act 1956 took a singularly restrictive approach to the definition of temples and, all in all, it was felt that to accommodate such eccentricity might open the floodgates to full-scale tax evasion by the inhabitants of Strathclyde. On an individual level, however, strange things sometimes happened which tended to reinforce Finlay's contention that the Garden Temple was possessed of a special character:

The Sheriff Officer finally came – one chill dusk, in a very large silver car. He looked like Saint-Just. He told us of the dreadful things that would be done to us. All this was much as expected, and clearly no charade. In the temple, he embarked (in the office part) on an inventory (items to be carried away). Incredibly, the main part of the temple (once he entered it) seemed to lay him under a spell; he tore up the inventory, purchased a work, and paid the money due to Strathclyde for us (writing the cheque there and then).[9]

27
Ian Hamilton Finlay with Alexander Stoddart,
Apollon Terroriste (1987), Little Sparta

This generous act could not, of course, stave off the Region's hounds for ever, and, a year later, a 'Schedule of Poinding', or summary warrant for the seizure of property, was served upon the Finlays, the bailiff's attentions being fixed most particularly upon 'a Porcelain Dryad representing Winter' and her two sisters in the garb of Autumn and Summer. By this time the stakes had also been raised by Finlay, who no longer sought discretionary relief on the Garden Temple, since this would leave its true status in limbo. The issue was now one of principle, and what Finlay demanded was mandatory rates relief, or at the very least the opportunity of presenting evidence in support of his claim to that effect.

His response to an invitation from the Region to attend an appeal in respect of discretionary relief in December 1982 was headed, probably for the first time, by the phrase 'LITTLE SPARTAN WAR':

I refer to your letter of 3.12, which claims to refer to 'previous correspondence' and advises us that the Finance (Appeals) Sub-Committee 'have agreed to hear an appeal' by us 'in respect of discretionary rates for Little Sparta'.

... To appeal for discretionary relief is to agree that we do not qualify for mandatory relief – which is (in turn) to agree that our description of the building (as a garden temple) is wrong. In short, you are offering us the opportunity to say we are wrong, this offer being camouflaged as an agreement to hear an appeal (which we have not asked for). This is very strategic but it is not acceptable here.

What is needed – what has been needed for a long time – is a discussion, not artificially circumscribed by strategy or inflexibility, or by simple dim-wittedness.[10]

Tempers growing predictably shorter, the Scottish Arts Council (SAC) was invited to mediate, but, despite a statutory duty to advise all Scottish government bodies on matters pertaining to the arts, could never quite bring itself to take a clear public line – a predictably pusillanimous position for which Finlay and,

at times, others have castigated it. On 28 January 1983, the Chairman of the Region's Finance Committee advised the SAC Director that:

> *While Mr. Finlay now appears to be claiming exemption for rates ... for the premises initially described by him as a 'gallery' but now described by him as a 'Garden temple', it is this authority's view that he does not so qualify In accordance with the policy of the Regional Council, I, as Chairman of the Finance Committee, have authorized that the Sheriff Officer be allowed to carry out a sale and I am not prepare to rescind that order unless the outstanding rates, together with the statutory addition, are paid forthwith.*[11]

Two weeks later, in the presence of the irregular band of Finlay supporters known as Saint Just Vigilantes and of several journalists, the Sheriff Officer from nearby Hamilton made an unsuccessful attempt to seize works from the Garden Temple in execution of Councillor Sanderson's decree. On this occasion, which became known as the First Battle of Little Sparta, he retired baffled, but returned a month later to make off with a number of objects; unfortunately, they turned out to be largely the property of an American museum, the Wadsworth Athenaeum in Connecticut, and after much huffing and puffing Strathclyde returned the lot in June 1988. According to a letter from the SRC Solicitor to the Scottish Legal Aid Board, "said Sheriff Officer attempted to make arrangements for a Warrant sale, but without success as auctioneers were unwilling to be involved in view of Press interest in disputed claims to ownership by third parties".[12]

This concluded the more picturesque phase of the Little Spartan Wars, but, despite the frequent intervention of distinguished artists, critics and academics from around the world, the Region continued its campaign of attrition. While the results were in the main as fruitless as those of 1983 Budget Day Raid, the strain and anxiety caused by this intermittent persecution certainly left its mark on both Finlays. For a brief moment in 1985 it seemed as though the Region had decided, as much for the sake of its own reputation as anything else, to acquiesce in a change of status for the temple, but the proposed change was purely cosmetic:

The garden temple has been declared a garden temple by the Regional Assessor. But the Region has immediately stated that it doesn't matter what it is called, the debt is to stand, and to multiply (i.e., the rates are to be demanded as before). The Sheriff Officer is concerned and wants to hire a Queen's Council, to defend us from him. Here we have several varieties of paradox.[13]

In February 1988, the Region seized a substantial sum from the Finlays' account with the Bank of Scotland, but were forced to return part of it after further legal challenges. Later that year, the Region's Solicitor, John H. Wilson, who actually met with Finlay at Little Sparta and studied submissions from the Saint Just Vigilantes, addressed the following letter to Finlay's solicitor:

... what we are dealing with here is a question of interpretation of statute. It does not follow, because your client asserts the spirituality and religious nature of arts in general and neo-classicism in particular or because you or I understand the point they seek to make, that the provisions of Section 22(1) of the Valuation & Rating (Scotland) Act 1956 as amended automatically apply to the circumstances of this case. I do not think they can be applied.[14]

This is an interesting document, inasmuch as it lucidly expounds the legal and philosophical differences between the parties. It also demonstrates the chasm separating them: to the Regional Solicitor's entirely reasonable (in terms of a legal and administrative discourse) point that "it does not follow", Finlay would retort, with equal reason (in terms of a cultural and humanistic discourse) that it bloody well ought to follow. Wilson, clearly an exceptional and unusual civil servant, went on to recommend a Summary Trial as the best way of resolving the issue:

There is ... a fundamental difference of view on the law which is simply not capable of being resolved by meetings or correspondence; only a Court can resolve the issue and a summary trial is a positive means to bring the issue to a

conclusion Given the importance to Mr. Finlay of the principle he wishes to establish, as he described it to me at our meeting, it seems to me this is the only way out of the legal impasse.

Indeed, so convinced was the Regional Solicitor of the essential equity of this solution that he offered to pay the costs of both parties, including the hiring of senior council to represent Finlay. Sadly, this civilized proposal came to nothing in the end, due largely to Finlay's continuing ill health and to pressing family problems.

Instead, during the course of a hearing held in early 1996 which hinged entirely on a minor procedural point of law, a motion entered on Finlay's behalf to have the Region's warrants set aside was defeated. No witnesses were called, nor was the case heard on the wider grounds of principle demanded by Finlay. As a result, the artist is once again liable to the Region for a considerable sum, Little Sparta is closed to the public, and the Garden Temple itself is no more, having been formally reclassified at Finlay's request as a storeroom, to which purpose it has now been put. The Scottish Arts Council continues to maintain that it cannot intervene in a legal dispute. For Finlay, who never nursed any illusions regarding the size of the windmills he had been tilting at, these facts are not unconnected:

No doubt there is something absurd in expecting the Region or the SAC to aspire towards a single world in which, to cite an early poem by Stephen Spender, 'Death and Jerusalem would glorify also the crossing sweeper', but what else could socialism, Jacobinism, mean? Should interpretation of the law be exclusive of tradition and culture? We are asked to divide ourselves into parts and then to surrender the better parts without a struggle. This is surely ignominious.[15]

© John Stathatos, 1997. First published in *Art and the Garden*, ed. Anne de Charmant (*Art & Design* no. 57), London 1997. Some corrections to grammar and punctuation, and for consistency, have been made for the present publication.

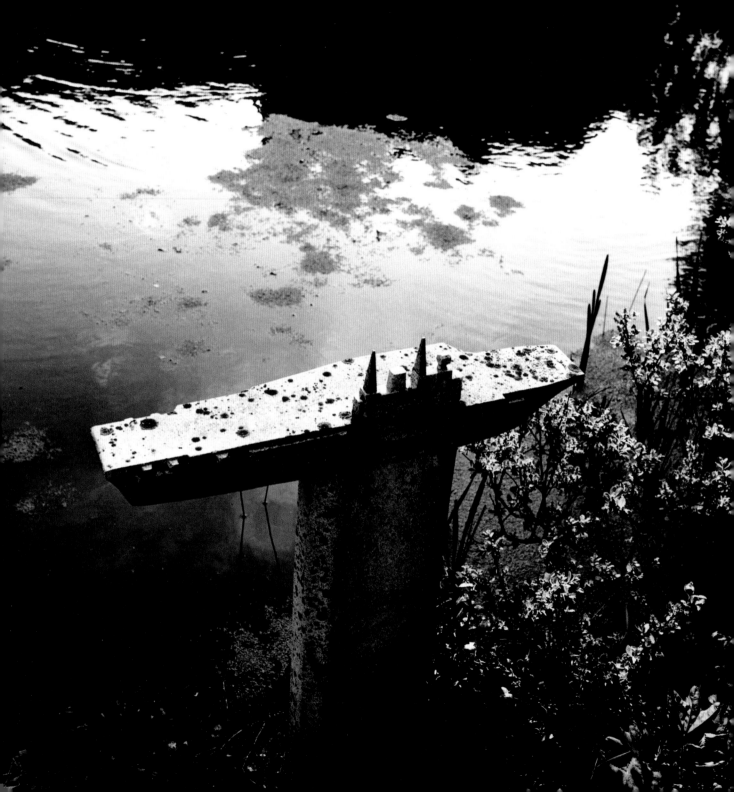

THE PETRIFIED WARSHIPS OF LITTLE SPARTA

Folksongs, even when they deal with the fantastic, are almost always grounded in 'common' sense. When a ballad asks 'how many ships sail in the forest?', it does so with ironic intent, begging the answer 'none', but in Little Sparta the correct answer is 'quite a few', for the seas of its thickets and woods are sailed by aircraft carriers, while nuclear-powered submarines cruise fathoms deep beneath the surface, only their conning-towers breaking above the green turf. Ian Hamilton Finlay's stone battleships are amongst his most powerful and enduring creations. The image of a petrified ship, stranded high and dry above the tide-line, is both poetically and visually powerful, its lineage as ancient as the oldest extant Greek text and as contemporary as Ian Banks's science-fiction novel *Use of Weapons*.

The concept is at heart an oxymoron, a flouting of the common sense exemplified, as it happens, by Finlay's English Colonel in the second Orkney Lyric from *The Dancers Inherit the Party*:

> The boat swims full of air
> [....]
> The hollowness is amazing. That's
> The way a boat
> Floats.

But such is not the case with these boats, nor is it for their many cousins in the Mediterranean. The coasts of Greece and Italy are full of petrified ships, boat-shaped rocks and reefs whose presence hints at supernatural intervention – here

28
Ian Hamilton Finlay with Vincent Butler,
Aircraft Carrier Bird-Table (1972), Little Sparta

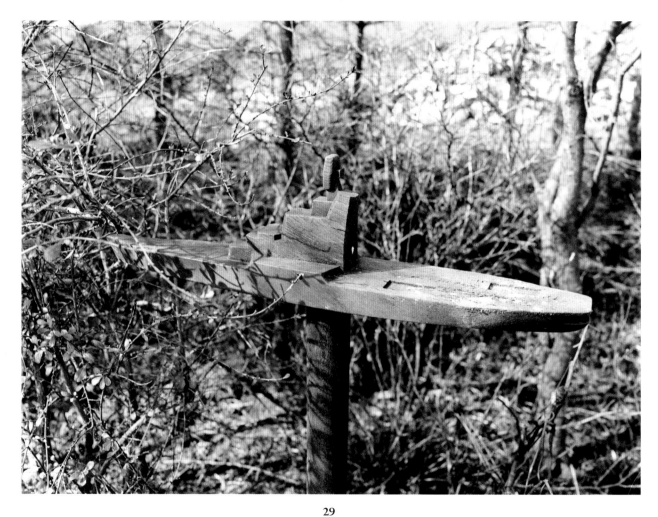

29
Ian Hamilton Finlay with John R. Thorpe,
Homage to the Villa d'Este: Aircraft Carrier Bird-Table (c.1973), Little Sparta

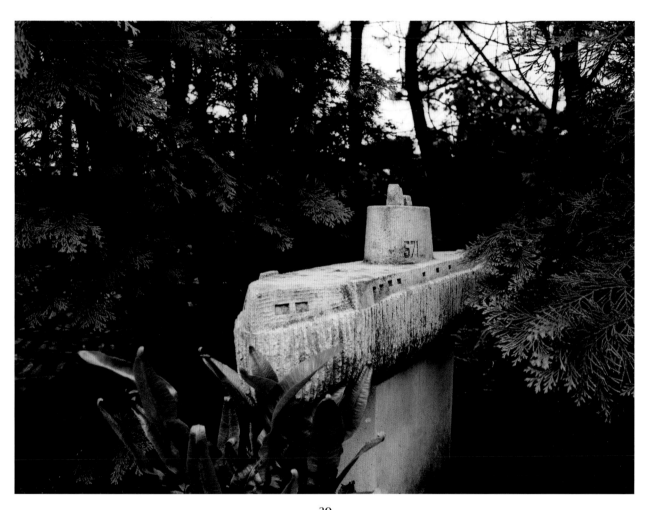

30
Ian Hamilton Finlay with John Andrew,
Homage to the Villa d'Este: USS Nautilus (1974), Little Sparta

a shipful of pirates turned to stone by Saint Demetrius, there a galley frozen by vengeful nereids. Inexplicably, a perfectly formed Chinese junk lies frozen off the south coast of Cythera. The tradition is an old one, for both Homer and Apollodorus tell of how, through the malice of Poseidon, the kindly Phaeacian ship which carried Ulysses to Phorcys was turned to stone with all her crew.

By name at least, Finlay's fleet acknowledges a later patrimony, since there are no fewer than four works entitled *Homage to the Villa d'Este* in Little Sparta, two by the edges of the Temple Pool (Aircraft Carrier Fountain and Aircraft Carrier Bird-Table), and two in the Roman Garden (Aircraft Carrier Bird-Bath and Aircraft Carrier Torso).

They refer to the elaborate sixteenth-century water gardens designed for Cardinal Ippolito d'Este at Tivoli, in the Roman Campagna, in which ships make two appearances, first as a convoy of twenty-two small boat-shaped fountains along the Alley of the Hundred Fountains, now almost entirely obscured by thick moss, and then, more impressively, in the form of a galley bearing an obelisk in the Fountain of Rome.

Boats are not otherwise particularly common in Italian Renaissance gardens, and when they are encountered it is almost always in association with fountains: the Villa Lante at Bagnaia has four particularly splendid examples. The seventeenth century added a few more, including the Fontana della Barca at the Villa Aldobrandini in Frascati. However, Giovanni Rucellai's description of his garden at the Villa Quaracchi in Florence includes an account of fantastic boxwood topiary in the shape, amongst many others, of ships and galleys.

Finlay's aircraft carriers, one (the fountain) in bronze, the others in stone, are an elegantly erudite twentieth-century echo of this almost forgotten tradition. Great gardens such as Little Sparta and the Villa d'Este are, among other things, sites of cultural commemoration and recapitulation; as Jean Starobinski reminds us, "the garden [is] a country of the memory". Designed at the time of the first Western rediscovery of classicism, the Villa d'Este is replete with references to Hercules, from whom the d'Este family claimed a mythical descent, and to ancient Rome, a substantial model of which dominates the piazza at the end of

31

Ian Hamilton Finlay with John Andrew,
Homage to the Villa d'Este: Aircraft Carrier Torso (1974), Little Sparta

32
Ian Hamilton Finlay with Michael Harvey,
Your Name – a Lyme Ketch (1970), Little Sparta

the Alley of the Hundred Fountains; in its turn, Little Sparta, cradle of the third neoclassical revival, pays appropriate homage to its predecessors by means of these sculptures.

Formal art-historical links of this kind are important, since a site like Little Sparta does not evolve in a cultural vacuum; nevertheless, as is the case with much of his work, the emotional power of Finlay's warships lies largely elsewhere, and is immediately apparent to even the most untutored of visitors. Above all, of course, is the wonderful idea of the garden as metaphor for the sea, a metaphor explicitly proposed by the *Mare Nostrum* plaque and endlessly elaborated throughout Little Sparta.

Wherever the ships have been placed, but particularly in the Roman Garden, the metaphor is extended visually by foliage (smooth, lanceolate leaves mimicking rolling waves, while evergreen fronds take on the appearance of foam), and aurally by the sound of wind rustling in the branches, a sound so uncannily like that of running water, or the ebb and flow of surf.

Finally, there are those puns, a mixture of the visual and conceptual, at once immensely sophisticated and artlessly self-evident, which are so characteristic of Finlay; for who could resist the conceit of an Aircraft Carrier Bird-Table or Bird-Bath whose upper surface (or flight deck) serves as a launching pad for chattering members of the finch and sparrow family? *Fly Navy* indeed!

First published in *Chapman*, nos. 78/79, October 1994

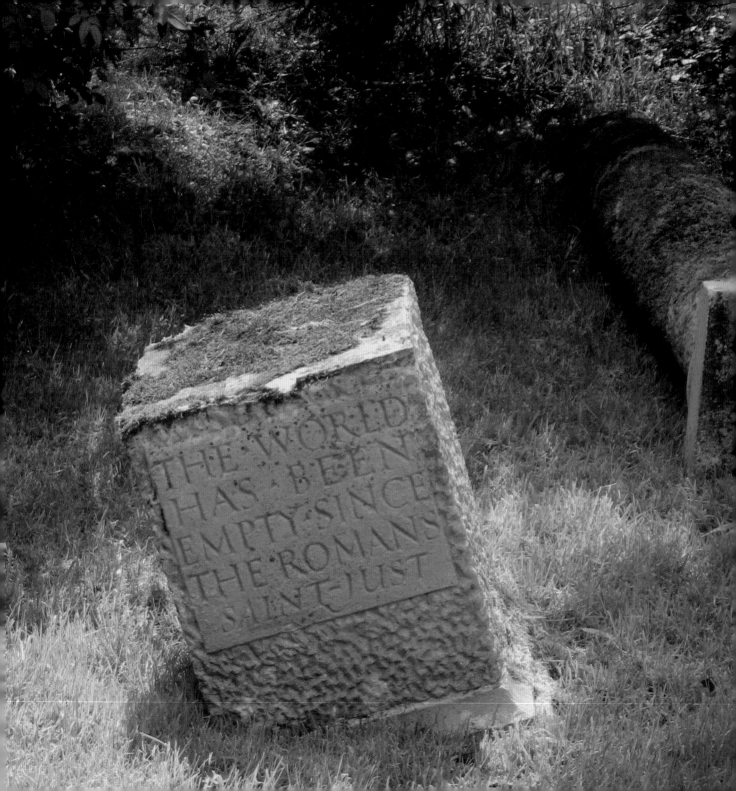

THE WORLD
HAS BEEN
EMPTY SINCE
THE ROMANS
SAINT-JUST

ELEGIAC INSCRIPTIONS

JOY SLEEMAN

A DISCUSSION OF WORDS IN THE WORK OF IAN HAMILTON FINLAY AND RICHARD LONG

Landscape, autobiography and the conjunction of words and landscape in elegiac and embattled modes are the themes of this exploration of the use of words in the work of Ian Hamilton Finlay and Richard Long. The discussion considers the artists' words in written communication and recorded interviews, as well as words that form an integral part of works of art. The narrative focuses on a particularly word-filled moment in the early 1980s; however, reflection on this period is sharpened by more recent reconsideration of both artists' practice in retrospective exhibitions and publications, notably the recent survey exhibitions of Long's work at the Scottish National Gallery of Modern Art in Edinburgh in 2007[1] and at Tate Britain in 2009,[2] and, among posthumous reconsiderations of Finlay's work, John Dixon Hunt's *Nature Over Again: The Garden Art of Ian Hamilton Finlay* (2008),[3] and Patrick Eyres's survey of the public works of Finlay in *Ian Hamilton Finlay: Selected Landscapes* (2007).[4]

My starting point is a visual correspondence between two photographs and a painting. One photograph is of a work by Finlay taken in 1984, the other is part of a

33
Ian Hamilton Finlay with Nicholas Sloan,
The World Has Been Empty since the Romans – Saint Just (1982), Little Sparta

SHADOWS AND WATERMARKS

A MUD WALL BY A RESTING PLACE NEAR THE END OF A 21 DAY WALK IN NEPAL

1983

34
Richard Long, *Shadows and Watermarks* (1983)

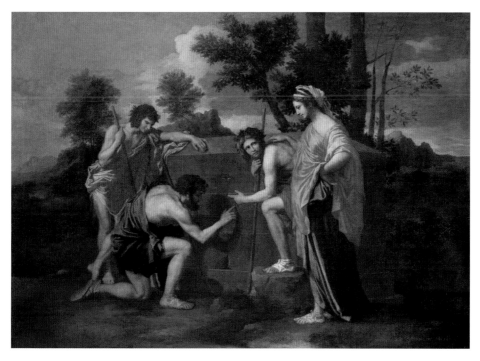

35
Nicholas Poussin, *The Arcadian Shepherds*, or *Et in Arcadia ego* (1636–37)
Musée du Louvre, Paris

work by Long from 1983. The painting, with one of the most famous inscriptions in art history, 'Et in Arcadia Ego', is Nicolas Poussin's *The Arcadian Shepherds* (fig. 35). The words inscribed on the tomb are in the first person, so that the person who once lived and now lies buried in Arcadia speaks to the living.

Long's photograph in *Shadows and Watermarks* was made "near the end" of an eventful twenty-one-day walk in Nepal in 1983 (fig. 34). The scene is "a mud wall by a resting place". The artist stopped to photograph watermarks,[5] and as he did so his shadow fell upon the wall and was captured in the image. By coincidence, the shadow falling on a flat plane set at an oblique angle to the picture plane

recalls a shadow in Poussin's *Arcadian Shepherds*, the veritable demonstration, according to Erwin Panofsky, of the invention of the elegiac.[6] But is it 'merely' coincidence?

In the catalogue to Ian Hamilton Finlay's exhibition *Coincidence in the Work of Ian Hamilton Finlay*, Christopher McIntosh wrote:

> *Coincidence is used to explain away any observation of two or more events or phenomena 'imitating' each other for which no causal explanation can be found. To the intuitive mind, however, there is nothing 'mere' about coincidence. On the contrary, coincidence is highly significant because it is the outward manifestation of the hidden interconnections between all things. It is, so to speak, the universe speaking aloud – and by the 'universe' I mean everything that surrounds us at a particular moment, including our cultural milieu.*[7]

Given his cultural milieu, was it so coincidental that Long should make an image that corresponded with Poussin's best-known painting? There are of course some notable differences between the two images, and these are not without significance.[8] Displaced from the centre of the image, the I/eye of the camera/artist does not coincide with the centre of the photograph's view as does the shadow of the crouching shepherd in Poussin's painting. Long's photograph captures the traces of a presence – the watermarks on the wall – but the shadow discloses an absence: the shadow of a figure outside the picture frame, an I/eye whose representation is displaced to the bottom right of the photograph and into the caption beneath it. Thus, the 'meaning' of the work is not given wholly within the image. We have to read the image together with the words in the caption outside the frame. As Long replied when asked by William Furlong in 1984 if, in using photography, "the photograph actually becomes the work", "Yes, it does, it becomes art in a different way. And the hand-written text underneath it gives the photograph a different meaning than it would have if the photograph was just a photograph."[9] Long's use of words here encourages a very personal reading and discloses a very private meaning for the work, whereas

36

Andrew Griffiths, *Monument to the First Battle of Little Sparta, after Poussin's 'Arcadian Shepherds' (Et in Arcadia ego), c.1638* (1984/86), from *New Arcadian Journal*, no. 23, 1986

Finlay's engagements with words – particularly his wordy outburst of 1983 – are among his most public, and popularly accessible, works.

The public dimension of Finlay's First Battle of Little Sparta was quite unprecedented in his work. "Choreographed with military precision art confronted political reality and, in triumph, captured the imagination of the public. The process was documented by BBC, ITV and TVam cameras, the Scottish and Fleet Street press and Saint Just Vigilante war photographers. Radio Clyde broadcast a running commentary."[10] During the battle Finlay had given interviews to the press from his battle HQ in the cow byre at Little Sparta;

after the War, the events including this monumental first battle were recorded and published as 'Despatches'. The *New Arcadian Journal* published these despatches in 1986, along with an array of illustrations by 'Official War Artists'. At the very heart of this publication – forming its centre-fold – is a re-enaction of Poussin's painting, Andrew Griffiths's *Monument to the First Battle of Little Sparta, after Poussin's 'Arcadian Shepherds' (Et in Arcadia ego), c.1638* (fig. 36).[11] The monument, a regular geometric shape in ordinary brick, domesticates the heroic monument but also recalls, in its form and material, the abstract geometric sculpture of minimalism, such as Carl Andre's work in bricks, and, as if in microcosm, the war-time bunkers, remnants of the Atlantic Wall that litter the British and mainland European shoreline.[12]

If Long's re-enactment of Poussin's *Arcadian Shepherds* was inadvertent, the New Arcadians' was direct and deliberate, transforming Finlay's monument to the First Battle of Little Sparta into the tomb in Arcadia. According to Panofsky, the elegiac innovation of Poussin's second version of *The Arcadian Shepherds* hinges on a change in interpretation, embodied in its composition, that almost compels the viewer to mistranslate the Latin phrase, allowing '*ego*' to refer to the departed person instead of its 'correct' translation as a personification of death.[13] The 'correct' translation – and the older *memento mori* interpretation of the phrase – is, Panofsky says, a peculiar, insular survival in Britain.[14] Finlay's and the New Arcadians' retranslations allow both interpretations to coexist, enabling a full sense of elegiac ambiguity.

These shifting interpretations circle around the I (*ego*) of the Latin tag. Louis Marin's view concerns how we as viewers enter the painting through the figure of the crouching shepherd as our avatar in the image, who reads the inscription as we read the painting, and whose shadow falls on the 'I' – the *ego* – as we become implicated in the painting.[15] In Long's inadvertent, modern and pastoral variation, the I or *ego* is instead an absence; the shadow and photograph (and the watermark traces) are intimations of a presence outside the frame that we as viewers cannot inhabit. The I/eye/*ego* is displaced outside the frame of the image into the artist, whose place we cannot imaginatively occupy in the same

way as we can the shepherd's. The I has already played, the photograph been exposed. There is no inscription to decipher inside the image, but only outside, in the caption that 'gives the photograph a different meaning than it would have if the photograph was just a photograph'. There is no I in this photograph that can be us, the I of a departed person, or of Death personified (death haunts the photographic process itself). And the I of the artist is always and ultimately unknowable. There is a text (of a life) beyond the frame to which we can be given various levels of privileged access. But it is a text we can never fully know. There is no I/eye, no shepherd reading as our avatar.

In the New Arcadian re-enactment, a first person – ME – is restored to the centre of the image, inscribed on the tomb/monument at the centre of the photograph. FLUTE BEGIN WITH ME – the exhortation for us to take up the flute/machine gun. As viewers we are enjoined to continue the song.

Finlay took delight in being characterized as both reactionary and revolutionary and held to his belief in the possibility of a classical art that could be accessible to anyone able and willing to read and decipher the inscriptions. These, although superficially elitist in their use of Latin or in their references to classical figures, gods, revolutionaries and poets, can nevertheless be opposed to the superficially accessible and democratic in that modern art in which 'meaning' always remains personal and unknowable.

In 1983 Long became embroiled in an uncharacteristic and unprecedented battle of words in the pages of the British art magazine *Art Monthly*. A word work that Long had recently made on that twenty-one-day walk in Nepal featured in published exchanges between the artist and the critic Lynne Cooke (fig. 37). Cooke referred to a change in Long's use of words:

Lately the texts have approximated more to a kind of concrete poetry. The litany of phenomenal objects or place names is now replaced by, or supplemented with, phrases referring to memory, mood and feelings. 'HAPPY ALERT BALANCED' (from WALKING WITH THE RIVER'S ROAR) seems to epitomize the artist's current stance.[16]

WALKING WITH THE RIVER'S ROAR

GREAT HIMALAYAN TIME A LINE OF MOMENTS

MY FATHER STARLIT SNOW

HUMAN TIME FROZEN BOOTS

BREAKING TRAIL CIRCLES OF A GREAT BIRD

COUNTLESS STONES HAPPY ALERT BALANCED

PATHS OF SHARED FOOTMARKS ATOMIC SILENCE

SLEEPING BY THE RIVER'S ROAR

A TWENTY ONE DAY FOOTPATH WALK NEPAL 1983

37

Richard Long, *Walking with the River's Roar* (1983)

Long, asserting his work as the "antithesis to so-called American 'Land Art'", which he termed "true capitalist art", invoked his recent journey, adding:

To walk the Himalayas (Walking with the River's Roar) is to touch the earth lightly, but is in fact more robust and dynamic, and has more personal physical commitment, than an artist who plans a large earthwork which is then made by bulldozers. I admire the spirit of the American Indian more than its contemporary land artists. [17]

More negative criticism had been mounting prior to Cooke's review. Simon Vaughan Winter had concluded a 1980 review of Long's work, "Richard Long

is fair game as an Aunt Sally; an inflated reputation can take a good number of pin-pricks. Sticks and stones may break his bones (as well as filling any number of art galleries), but words are unlikely to hurt him."[10] Long spoke to William Furlong of his reasons for breaking the silence he had maintained, with a few exceptions, right back to his very first exhibitions:

> *In the early years I had this naïve idea that the work should speak for itself, but of course it doesn't actually work like that. I think if the work becomes well known to a certain extent then people start writing about it anyway and it's a bit like Chinese whispers. If there are only a few articles written by misinformed people, if that's all there is about you, then those articles take on an importance that they shouldn't have. So I did my first piece of writing in a way to try and set the record straight. That was the reason for doing the statements, the 'Five, six, pick up sticks' (in 1980).*[19]

The fight back could be subtle, even if rooted in a response to specific criticism. Long does not name names when referring to the "few articles written by misinformed people", but his conversation with *Audio Arts* is full of details that seem intended to counter the kinds of criticism made by Rasheed Araeen and others – the human element in the story of his walks, evidence of his engagement with the people he meets along the way, attitudes to the possession of land and the morality of art.[20] But if the motivation was fighting back – a reactive response rather than one born out of a need to express his ideas in words or writing – it was also at much the same time, and with rather different motivation, that Long began using words as the sole material in some of his works, which at the time he termed 'word pieces'.[21] As he explained:

> *I really wanted another way of expressing the whole idea of a walk or even a sculpture. Sometimes, I would use the photograph to represent the idea of a walk but that was just like one moment and so, sometimes, I thought I could use words to give the whole, complete, total idea.*[22]

Thus in the early 1980s Long came to the defence of his work in words partly out of a sense that to believe works could speak for themselves was naïve, and also out of a distrust of the words of others to speak adequately for him. Long's 'textual turn' was also an autobiographical turn. Works made at this time, particularly those made on the walk in Nepal in 1983, *Shadows and Watermarks* and *Walking with the River's Roar*, are both autobiographical and elegiac.

Long's inadvertent recreation of a central motif of Poussin's painting is only given its full elegiac resonance in a series of postscripts or 'words after the fact' by the artist, and those meanings are insistently autobiographical. Only Long's autobiographical recollections reveal the significance of the encounter with 'My Father' while Walking with the River's Roar in Nepal in 1983. In conversation with Patrick Elliot, the curator of Long's 2007 exhibition in Edinburgh, some months before the exhibition opens, Long is reminded of his father by one of the sculptures that is to be in the forthcoming show:

> *The Stone Line* [fig. 38] *in the Scottish National Gallery of Modern Art's collection will occupy the biggest room. It's the first cut slate work I made – it's the prototype of all those other stone lines. I remember it because it was made for a group show at the Hayward Gallery in 1980. My father died in the morning, I saw my mum, then I came up on the train and made that work. It was an emotional day.*[23]

Reminded of his father on a walk in the landscape in Nepal three years later, the inscription of that simple name 'My Father' in the text work becomes an epitaph. The photographic work *Shadows and Watermarks*, made near the end of that same journey, might become "itself an epitaph and, more specifically, the author's own monumental inscription or autobiography". The words are Paul de Man's describing Wordsworth's 'Essay upon Epitaphs', that "exemplary autobiographical text" "which turns compulsively from an essay *upon* epitaphs to being itself an epitaph".[24] The I absent in Long's repetition of Poussin's work

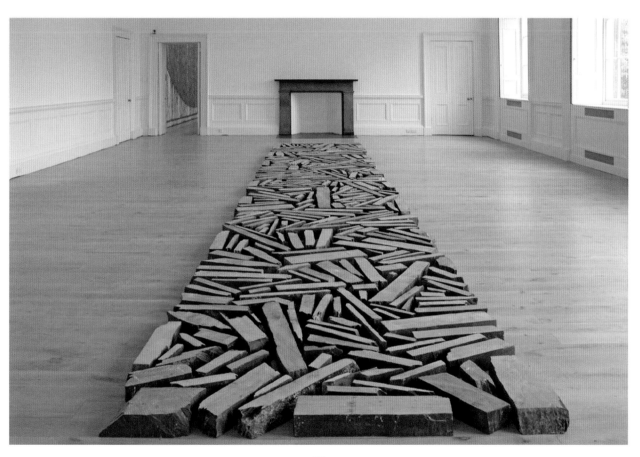

38
Richard Long, *Stone Line* (1980)
Scottish National Gallery of Modern Art

is not only the I of death – a *memento mori* (by a resting place, near the end) but also the I of a (recently) departed person. This person speaks in the *River's Roar*, a reminder in a distant landscape of shared footsteps beside another great river, the river of Long's childhood in Bristol.[25]

The final section of Wordsworth's essay is an epitaph he himself composed, a quotation from his own work 'The Excursion'. It takes the form of an epitaph for a deaf man who is unable to hear the very kinds of sounds recalled in Long's *Walking with the River's Roar*: "And this deep mountain valley was to him / Soundless with all its streams / ... The agitated scene before his eye / Was silent as a picture".[26] It seems all the more appropriate then that the elegiac import and the excess of sound in Long's Nepal walk come at a moment when the artist broke his own silence and entered into a highly public critical discourse, on the subject of himself and his work. Long's pictures are no longer silent.

Long's (re)discovery of working exclusively with words revisited a piece made a decade earlier for an important exhibition, *When Attitudes Become Form*, curated by Harald Szeemann in Bern.[27] If this work, *A Walking Tour in the Berneroberland*, was, in Long's words, "a sort of strange one-off",[28] one of the first of these new word works, *A Straight Northward Walk Across Dartmoor* (1979; fig. 39), reworked very familiar terrain, Dartmoor, where Long had made some of his first significant works. This particular landscape is the location of his first venture into film,[29] and of a very early book work, *Sculpture for Martin and Mia Visser*, which was made on Dartmoor concurrently in 1969 while waiting for a suitable day for filming. With the Straight Northward Walk, Long took the scale of longer walks – the ten-mile walks in the film work for Schum, or *A Line in England 1968* – and presented it on the page and in the frame in the form of one of his early walks of a shorter distance, that is, *A Line Made by Walking England 1967*. It also had the layout of a map work, with the sequence of words proceeding northwards, from the bottom to the top of the page. When Martina Giezen put it to Long, "This is a very typical work?", he replied, "Yes".[30]

A work made in 1982 was less typical, but describing it to Giezen led Long to make a revealing statement about the meaning of words and his intention in

RAILWAY LINE
A PAIR OF BUZZARDS
THISTLES
IRISHMAN'S WALL
WHITEHORSE HILL
STATTS HOUSE
WINNEY'S DOWN
EAST DART RIVER
SANDY HOLE PASS
A DEAD SHEEP
BROAD DOWN
SHEEP BONES
COTTON GRASS
CLAPPER BRIDGE
MIDDAY
GORSE
GRANITE BOULDERS
SECOND FOX
SMALL WOOD
WEST DART RIVER
NAKER'S HILL
FOX
OLD CHINA CLAY WORKINGS
RED LAKE
PONIES
FIRST SUN
CAIRN
BRACKEN
STONE ROW

A STRAIGHT NORTHWARD WALK ACROSS DARTMOOR

ENGLAND 1979

39
Richard Long, *A Straight Northward Walk Across Dartmoor* (1979)

A THREE DAY BICYCLE RIDE

BIRTHPLACE BRIDGE THE FAST YEARS
1977 CROSSING PLACE FOSS WAY CHALK VALLEY
FELLOW TRAVELLERS ON THE SAME ROAD FLINT SOURCE FRIEND
HEATHROW AIRPORT HERE THERE
DEAD STOAT ALDERMASTON BORROWED TIME
SILBURY HILL 316 MILES FAMILY

1982

40

Richard Long, *A Three Day Bicycle Ride* (1982)

this particular work, *A Three Day Bicycle Ride* (1982; fig. 40): "'Dead stoat' means I passed a dead stoat in the gutter I passed Aldermaston in the morning, which is a very powerful and symbolic place because that's where they design missiles which could blow the world up ... so we are living on borrowed time."[31] When they returned to this work later the conversation, Giezen remarked, "It worries me that we ended the [first] book with an untypical work!", to which Long replied:

No, it's fine. But the work is relatively complicated. All these layers of meanings. Some of my works are very simple [he gives some examples]. *With the Cycle Ride I mention the crossing place of other sculptures, old friendships, the source*

of a sculpture, of a flint sculpture that I made some years later, autobiographical things, my family. The use of Heathrow Airport is a very jarring ... a difficult image which was deliberate. In a way I wanted to make a work which was absolutely equally modern and pastoral, and about the equality of places passed along a journey.[32]

At first, then, words appear to be a means by which Long renews his work in a different form without it seeming a 'new' departure. He does this by revisiting the sources of his work, but also the source more literally – his birthplace and home in Bristol. In the publication of *A Straight Northward Walk Across Dartmoor* in *Aggie Weston's*, a periodical edited by Stuart Mills, the cover of the publication shows a scene on the River Avon just down river from the Clifton Suspension Bridge in Bristol.[33] *A Three Day Bicycle Ride* begins with 'Birthplace' (Bristol) and then 'Bridge' (Clifton Suspension Bridge), while the work made on the walk in Nepal in 1983 begins and ends with a river. Both share references to time and time passing and to shared journeys – in *A Three Day Bicycle Ride*, 'the Fast Years', 'Borrowed Time', 'Fellow Travellers on the Same Road', and in *Walking with the River's Roar*, 'Great Himalayan Time', 'A Line of Moments', 'Human Time' and 'Paths of Shared Footmarks'.

The word pieces bring the poetic form of prosopopeia to a new level of literalness in Long's work. With their references to time they also act as a *memento mori*, reminders of the transience of human life. Unlike the sticks and stones of his earlier work, these elements in the landscape have begun to speak in actual words. Long is at pains to say that they are not poetry, although they seem to use poetic devices. Acknowledging the autobiographical content and the use of prospopeia, these works seem very close to the elegiac mode of, for example, Wordsworth's 'Essays upon Epitaphs'. [34]

Proposopeia is a form used particularly in funerary oration and inscription, where the dead person is made to speak to the living:

Telling you himself that his pains are gone; that a state of rest is come; and he conjures you to weep for him no longer Thus is death disarmed of its sting, and affliction unsubstantiated. By this tender fiction, the survivors bind themselves into a sedater sorrow, and employ the intervention of the imagination in order that the reason may speak her own language earlier than she would otherwise have been able to do. This shadowy interposition also harmoniously unites the two worlds of the living and the dead by their appropriate affections.[35]

Paul de Man argued that Wordsworth's 'Essays upon Epitaphs', like the epitaphs themselves, are also a form of autobiography.[36] Long acknowledges the autobiographical content in his *Three Day Bicycle Ride*, and it is emphasized even more fully in the works (such as *Walking with the River's Roar*) that use words expressing emotional states or feelings in the first person, which is unusual in Long's work.

Finlay's extensive engagement with the elegiac often returned to Poussin's neoclassical painting and to the inscription at its heart, 'Et in Arcadia ego', and to the first person I – the person in the tomb who speaks, or the personification of death – at the very centre of that inscription. But arguably the elegiac first enters Finlay's work in an encounter with modern rather than historic painting, or paintings in reproduction – Ad Reinhardt's black paintings. Several writers have discussed this crucial encounter, most recently Michael Corris, exploring the dialogue from Reinhardt's perspective in his recent book on the artist.[37] In a letter to Reinhardt Finlay wrote: "I have started to feel that humour is not a way of doing things – that there ought to be evening poems as well as afternoon ones – and your pictures please me very much by having this distance, they are absolutely art and not by being funny".[38]

Where humour had served as one means of imbuing works with the distance necessary to restore a sense of aura in Finlay's poetry – "the unique sense of distance, however close it might be"[39] – Finlay saw, through Reinhardt's work, a way to create that distance in an evening mode, to create "evening poems as well as afternoon ones". Yves Abrioux connects this directly to Virgil's discovery

118

of the evening in his poetry. He argues, following Panofsky, that if of Virgil "with only slight exaggeration one might say that he 'discovered' the evening",[40] then Finlay rediscovered the auratic effect of evening in his use of the elegiac in and beyond his garden at Little Sparta.

Perhaps more remarkable than the fact that Finlay rediscovered the elegiac through Reinhardt is the fact that Finlay's encounter with Reinhardt's notoriously difficult-to-reproduce paintings was via reproduction. Finlay explained the reason to Reinhardt – his "panics" at visiting galleries. This is an early indication, from a time before Finlay moved to Stonypath, of the agoraphobia that made him reluctant to venture beyond the boundaries of that property until very late in life.[41] In Finlay's work there is frequently a tension between the proximity of the everyday and the evocation of an auratic and nostalgic distance from the past. By necessity (his agoraphobia) and by an accident of history (his birth in the twentieth century) Finlay is distanced from both contemporary and classical 'worlds'. A sense of estrangement is a recurrent theme in his correspondence and his work, but there is also a tension between this and a sense that things or people are in very close proximity despite their historical or geographical distance. Finlay recognized that a sense of estrangement from the past was something that had not always been felt by 'moderns' at all times in history. His exemplary models were the leaders of the French Revolution, who looked to and lived the example of the classical past as well as projecting the modernity of their revolutionary achievement into the future. Here were men and women who were quintessentially modern, aware of their own place in history, living fully cognizant of their indebtedness and connectedness to the past. The extent of Finlay's identification with these revolutionary figures led him to describe himself as a "modest wee jacobin",[42] and to speculate humorously on whom he might vote for in a British general election since "Robespierre is not standing".[43] A recurring subject in Finlay's correspondence is the mention of someone distant in time or place that he "would like to talk to". This is usually followed by something along the lines of "… and there aren't many people I feel like that about nowadays", to give a sense of the rarity of their qualities.[44] To his friend and patron Ronnie

Duncan, Finlay wrote: "How happy I would have been to have A. S. [Albert Speer] as a friend. A thing I rarely feel about people."[45] Sometimes this conversation became a 'live' correspondence, as it did with Reinhardt, occasionally leading on to a collaborative work, as was the case with Albert Speer. The humorous and jarring effect of bringing together a dialogue with a historical figure and the quotidian life at Little Sparta – a quintessential feature of Finlay's work – is brought out in a letter from Finlay to Tom and Laurie Clark: "I have written to Albert Speer, and given him my 'phone number (in case he needs it). This adds to the interest when the 'phone rings. (It is either Sue's Mother, or Albert Speer)."[46]

Finlay's poetic universe is a community of the living and the dead, of people geographically distant as well as close collaborators. It is informed by a nostalgia for a utopian age of shared, Enlightenment discourse but at the same time it is quintessentially modern and contemporary. Finlay's networked community is attuned to our electronically connected age and is further evidence, should we be in any doubt, that the existence of such structures predates its inauguration in electronic technology. During his lifetime Finlay, by necessity and disposition an inveterate correspondent and conversationalist, implicated hundreds of individuals in the extended narrative of his work and biography. There are voluminous collections of Finlay's correspondence, notes, drawings and recorded interviews in archives, libraries and private homes worldwide. To cite one example, the Lilly Library in Bloomington, Indiana, has a collection of correspondence, dating from 1953 to 1972, that lists the names of nearly 400 correspondents from this period alone. A complete list of Finlay's correspondents would no doubt provide a veritable Who's Who of the art world and, should anyone attempt the mad scheme and plot the connections on a map, demonstrate the manifest possibilities for a worldwide network centred on a garden in Scotland.[47]

The dialogues were productive of both work – the driving force behind collaborative works, commissions and proposals – and conflict. One might go so far as to say that just as conflict drove the narrative of Finlay's work as a dialectical force during his life, that conflictual dynamic has continued after

his death, no doubt with the potential for many more battles from beyond the grave. In John Dixon-Hunt's *Nature Over Again: The Garden Art of Ian Hamilton Finlay*, the first chapter is entitled 'Words of a dead poet ...'; the telling ellipsis addressed to the living, who are now enjoined to continue interpreting Finlay's works in "responses that can, will, or even perhaps must, fly free of [his] authorial and authoritative instruction".[48]

For both Finlay and Long the period around 1980 marked something of a watershed, a moment when words came to the fore and played a crucial role in each artist's work. For Long the making of any public statement was a novelty and a radical departure and was accompanied – or just preceded – by the adoption of words as the medium for wall- and page-based text pieces. For Finlay, no stranger to verbal skirmishing, the period marked an escalation from a war of words conducted largely via semi-private correspondence to one played out 'live' and in public, in the local and national media. What Eyres describes as the "hot phase" of the long-running Little Spartan War in 1983–85 was preceded by two highly significant textual inaugurations in about 1979, the publication of *The Monteviot Proposal* (1979), an unrealised proposal for a public project that Eyres argues forms the blueprint for Finlay's subsequent public works, and the re-naming of Finlay's garden at Stonypath as 'Little Sparta'.[49] For both artists these departures marked an exponential increase in public wordiness. At a time when the question of artists' words and the status of authorial intent were prominent in art discourse,[50] the timing of these eruptions of the verbal seems more than mere coincidence. Despite the artists' differing career trajectories up to that point, they display a marked similarity in their regard for the status of words or text as integral and important aspects of their practice.

In a statement published in 1982 Long asserts: "A sculpture, a map, a text, a photograph; all the forms of my work are equal and complementary".[51] Finlay's statement for a survey of British artists' books (1983–93) seems to concur with Long in saying: "My 'artist's books' are important to me, but so are my garden installations, prints, cards, or whatever: in short, every form has its own merits and possibilities".[52]

Long's partial retrospective at the Scottish National Gallery of Modern Art, Edinburgh, in 2007 was accompanied by the simultaneous publication of his *Selected Statements & Interviews* edited by Ben Tufnell.[53] As the title makes clear, these are 'selected' statements and interviews; indeed, most of them had been published before. But they are representative of Long's output in one crucial sense – in demonstrating the virtual absence of words – written or spoken – by the artist prior to his first publication of a series of statements about his work, 'Five, six, pick up sticks', in 1980.[54] Long had tried to engage wordlessly with an audience for his work – for example in his slide shows: "All I do sometimes is play music to slides of my work. One slide is shown for the duration of the one piece of music. If I show twenty slides I play twenty pieces of music."[55] By contrast, Finlay's professional career began with words. His first publications were short stories and poems, and throughout his life he preferred to be regarded as a poet. Patrick Eyres claims of Finlay's work generally that "his starting point is the word".[56] Despite their very different starting points in relation to the use of words in their practice, by the early 1980s words had gained equivalence with other forms of mediation in both artists' work.

Retrospective exhibitions, in the case of Richard Long (at the Scottish National Gallery of Modern Art, Edinburgh, in 2007 and Tate Britain, London, in 2009), and the final closure of death, in the case of Ian Hamilton Finlay (in March 2006), afford opportunities for the reconsideration and reassessment of both artists. Words play an important role in those processes as well as in the work of both artists. The monument to the First Battle of Little Sparta as enacted by New Arcadian shepherds now serves as an epitaph for Finlay, transformed into a silent tomb, the first and last work encountered by visitors to Little Sparta at the boundary of his garden. It is Finlay's words that are enabled to speak, but now the song must be continued, accompanied by the flute and/or machine gun – by 'me', the subject addressed in the inscription, indicated by the pointing shepherds. Beyond the silence of the tomb it must be spoken or sung by others. This fitting epitaph recalls Finlay's discovery of the elegiac in the encounter with Reinhardt – his realisation that there should be evening poems as well as afternoon ones

– and reminds us that those poems might be played out in the notes of a flute or the rattle of machine-gun fire, as harmony and discord, both inescapable aspects of modern culture.

Long's work is accompanied by an increasingly personal autobiographical narrative. Often implied in early presentations, Long's personal presence, through his own words and autobiography, have lately gained a much greater prominence in publications and exhibitions of the artist's work, where once silence and reticence were more typical. Just a few weeks before Long's exhibition in Edinburgh opened (at the end of June 2007), the artist was to experience a close encounter with death in the landscape – this time his own, as he sustained his first (and so far only) potentially life-threatening injury while walking in the Cairngorms. His broken leg was still in plaster when he made the large-scale mud wall works for the Edinburgh show, a quite remarkable physical feat.

The Long of 2009 is far from silent. In the exhibition at Tate Britain, his words formed the information presented in wall texts in each of the exhibition displays, as well as the words that appeared in the many word works displayed in the exhibition. Words spoken by the artist were the soundtrack to films about his work accompanying the exhibition, and were published in transcripts of interviews in the exhibition catalogue. Even the postcards available in the exhibition shop included classic word works, such as *Walking with the River's Roar*. Indeed the autobiographical and elegiac aspects of Long's work discussed in this essay were very much in evidence in almost every aspect of the 2009 exhibition, from the prominence of the river of his birthplace and home in Bristol to the photograph of the artist walking on Dartmoor with his father in 1968.[57]

If the 2009 exhibition at Tate Britain was the most elegiac representation of Long's work to date, it is perhaps the frequent autobiographical instances and the recent Poussin-esque encounter with near death in the landscape that have given this historic mode new currency in Long's work. As such it offers yet further evidence for Panofsky's claim of the peculiar survival of the elegiac in British art.

© Joy Sleeman/*Sculpture Journal*
First published in *Sculpture Journal*, vol. 18, issue 2, 2009

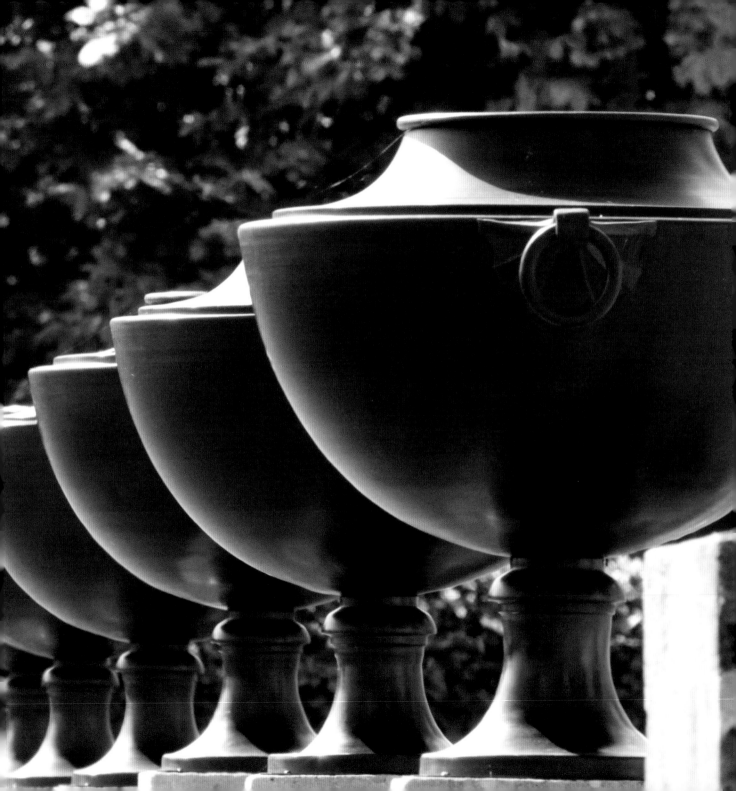

NOTES TO THE ESSAYS

PREFACE

1 Letter from Finlay to S.B., 11 November 1975.
2 Alec Finlay (ed), *Ian Hamilton Finlay – Selections*, Berkeley, University of California Press, 2012, pp. 7, 10.
3 Stephen Bann (ed), *Stonypath Days: Letters between Ian Hamilton Finlay and Stephen Bann 1970–72*, London, Wilmington Square Books, 2016, p. 72.
4 Edward Hyams, *The English Garden*, with photographs by Edwin Smith, London, Thames and Hudson, 1966, p. 55.
5 Ibid., p. 54.
6 John Dixon Hunt and Peter Willis (eds), *The Genius of the Place: The English Landscape Garden 1620-1820*, London, 1975, pp. 289–97.
7 Stephen Bann, 'A Description of Stonypath', *Journal of Garden History*, vol.1, no. 2, April–June 1981, p.113.

INTRODUCTION

1 This is the extended title of George Perkins Marsh's book *Man and Nature: Or, Physical Geography as Modified by Human Action* of 1864.
2 Thompson, *The Making of the English Working Class*, 1991, p. 43.

A PASTORAL ROMANCE INCLUDING
DIALOGUE AND VERSE

1 *Poussin and Nature: Arcadian Visions*, ed. Pierre Rosenberg and Keith Christiansen, 2008.

THE GARDENING PRACTICES OF
IAN HAMILTON FINLAY

1 C.O. Sauer, *The Morphology of Landscape*. (University of California Publications in Geography, no. 22) 1925, pp. 19–53.
2 Ian Hamilton Finlay, quoted on BBC's *South Bank Show* in 1983.
3 Ian Hamilton Finlay, quoted on BBC's *South Bank Show* in 1983.

PIETY AND IMPIETY:
THE LITTLE SPARTAN WARS

1 Ian Hamilton Finaly (IHF) in discussion with the author, 10 May 1997.
2 Assistant Director of Finance, Strathclyde Regional Council, to IHF, 29 December 1978.
3 Depute Director of Finance, Strathclyde Regional Council, to IHF, 2 March 1979.
4 IHF to Director of Finance, Strathclyde Regional Council, 6.3.79.
5 IHF to Director of Administration, Strathclyde Regional Council, 19 March 1979.
6 IHF to Department of Finance, Strathclyde Regional Council, 4 September 1979.
7 IHF to the author, 9 December 1980.
8 From the application filed by Ian and Sue Finlay in September 1981.
9 IHF to the author, 21 October 1982.
10 IHF to Chief Executive's Department, Strathclyde Regional Council, 7 December 1982.
11 Councillor David Sanderson, JP, Chairman of Strathclyde Regional Council Finance Committee, to Timothy Mason, Scottish Arts Council, 28 January 1983.
12 Strathclyde Regional Council Solicitor to Scottish Legal Aid Board, 4 May 1988.
13 IHF to the author, 2 January 1985.
14 Strathclyde Regional Council Solicitor John H. Wilson to Angela Mullane, IHF's solicitor, 21 October 88.
15 IHF to the author, 27 May 1997.

ELEGIAC INSCRIPTIONS BY JOY SLEEMAN
The research for this article was supported by the Arts and Humanities Research Council (AHRC). Joy Sleeman would personally also like to thank Patrick Eyres and Richard Long.

1 Richard Long, *Walking and Marking*, Scottish National Gallery of Modern Art, Edinburgh, 30 June – 21 October 2007.
2 *Richard Long: Heaven and Earth*, Tate Britain, London, 3 June – 6 September 2009.

3 John Dixon Hunt, *Nature Over Again: The Garden Art of Ian Hamilton Finlay*, London, Reaktion Press, 2008.

4 *New Arcadian Journal*, nos. 61/62, 2007.

5 Several people to whom I have shown this picture read them as piss marks, perhaps an appropriate marking of territory.

6 E. Panofsky, 'Et in Arcadia Ego: Poussin and the Elegiac Tradition', in *Meaning in the Visual Arts*, London 1955, reprint Harmondsworth 1993, pp. 340–67.

7 C. McIntosh, *Coincidence in the Work of Ian Hamilton Finlay*, Graeme Murray Gallery, Edinburgh, 1980.

8 McIntosh developed the theme of coincidence with reference to a then forthcoming book that claimed Poussin's painting as the key to the location of hidden treasure "connected with some secret, inner tradition within Christianity" with "vast ramifications stretching back into history and involving the Templars, the Cathars, the Rosicrucians, the Merovingian Kings and the cult of Mary Magdalene", ibid. *The Holy Blood and the Holy Grail* was published in 1982. At the time of Finlay's death, the authors, Michael Baigent and Richard Leigh, were locked in a much publicized court battle with Dan Brown, author of the bestseller *The Da Vinci Code*, who they claimed had plagiarised the "whole architecture" of their plot.

9 Long in an interview with Audio Arts in 1984; B. Tufnell (ed.), *Richard Long: Selected Statements and Interviews*, London, Haunch of Venison, 2007, p. 61.

10 *New Arcadian Journal*, no. 23, Autumn 1986, p. 6.

11 Ibid., pp. 19–20.

12 Celebrated by Paul Virilio in *Bunker Archéologie*, Centre Georges Pompidou, Paris, Centre de Création Industrielle, 1974, and in English as *Bunker Archaeology*, New York, Princeton University Press, 1994, 2nd edition 2009. Eyres remembers Finlay studying *The Architecture of Aggression* by K. Mallory and A. Ottar, Oxford, Architectural Press, 1973, and recounted his giving a slide show of his tour of the Netherlandish section of the Atlantic Wall at Little Sparta: conversation with the author, July 2008. See also 'The Atlantic Wall', *New Arcadian Journal*, no. 14, 1984.

13 Panofsky, as at note 6, pp. 362–63.

14 Panofsky says "England" rather than "Britain», and traces the survival of this "insular" tradition into the twentieth century with examples in the painting of Augustus John and in Evelyn Waugh's novel *Brideshead Revisited* (1945): ibid., pp. 356–57.

15 As part of a broader discussion of how paintings engage their viewers, Marin's interpretation explores how the classical tradition includes a community of viewers who can enter into the painting's deciphering: L. Marin, *To Destroy Painting*, trans. Mette Hjort, Chicago and London, Chicago University Press, 1995.

16 L. Cooke, 'Richard Long', review of exhibitions at Arnolfini Gallery, Bristol, 26 March – 7 May, and Anthony d'Offay, London, 30 March – 14 May, *Art Monthly*, no. 66, May 1983, pp. 8–9. Finlay remarked that some of Long's word pieces are concrete poetry: author's notes of a conversation with Finlay at Stonypath, 9 March 1992.

17 R. Long, 'Correspondence: Richard Long replies to a critic', *Art Monthly*, no. 68, July/August 1983, pp. 20–21.

18 Simon Vaughan Winter, *Artscribe*, no. 26, December 1980, pp. 46–47.

19 From an interview given in London in February 1984: R. Long, 'Interview with William Furlong' (1984), originally published as an audio tape by *Audio Arts*, London, 1985; Tufnell, as at note 9, p. 62.

20 See R. Araeen, 'Correspondence: Long walks round the world', *Art Monthly*, no. 69, September 1983, p. 25, and P. Overy, 'Richard Long', review of an exhibition at the Whitechapel Art Gallery, London, *Art Monthly*, no. 4, February 1977, p. 21.

21 'Text work' is the description now used by the artist to designate a work composed of text that can be – and indeed often has been – displayed in many different formats and sizes, from printed postcards to large-scale vinyl lettering applied directly on to walls in exhibitions. The decision as to scale and material used is pragmatic, utilizing whatever is most appropriate and practical for the given scale and location.

22 Tufnell, as at note 9, p. 60.

23 'Richard Long in conversation with Patrick Elliott', 7 March 2007, in *Richard Long: Walking*

and Marking, National Galleries of Scotland, Edinburgh, 2007, p. 57. The exhibition at the Hayward was *Pier + Ocean*, 8 May – 22 June 1980.

24 P. de Man, 'Autobiography as De-Facement', in *The Rhetoric of Romanticism*, New York, Columbia University Press, 1984, p. 72.

25 Long later recounted the importance of walks along the River Avon with his father: see R. Long, 'Excerpts from Stepping Stones, a conversation with Denise Hooker', in idem, *Walking the Line*, London: Thames and Hudson, 2002, p. 307.

26 W. Wordsworth, 'Essays upon Epitaphs III', in W.J.B.Owen and J.M. Smyser (eds.), *The Prose Works of William Wordsworth*, vol. II, Oxford, Oxford University Press, 1974, p. 94.

27 *When Attitudes Become Form: Works – Processes – Concepts – Situations – Information*, Kunsthalle, Bern, 22 March – 27 April 1969.

28 Tufnell, as at note 9, p. 60.

29 *Walking a Straight 10 Mile Line Forward and Back Shooting Every Half Mile*, Dartmoor, England, 20 January 1969, for *Land Art*, Fernsehgalerie Gerry Schum, first broadcast on television in Germany on Programm 1, 15 April 1969.

30 *Richard Long in Conversation with Martina Giezen*, Holland, MW Press, 1985–86, Part 2, p. 12.

31 Ibid., Part 1, p. 21.

32 Ibid., Part 2, p. 10.

33 *Aggie Weston's*, no. 16, Winter 1979. The cards that announced Long's shows at Konrad Fischer's gallery in Düsseldorf encapsulate a journey down river, from Clifton Suspension Bridge (illustrated on the card to his first solo show in 1968) to Pill Ferry (shown on the card to his second in 1969).

34 Wordsworth, 'Essays upon Epitaphs', as at note 26, pp. 45–96.

35 Ibid., p. 60.

36 De Man, as at note 24, pp. 67–81.

37 M. Corris, *Ad Reinhardt*, London, Reaktion, 2008, p. 112. See also S. Howe, 'The End of Art', *Archives of American Art Journal*, vol. 14, no. 4, 1974, p. 5, and Y. Abrioux, in *Ian Hamilton Finlay: A Visual Primer*, London, Reaktion, 1985, p. 241.

38 Corris, ibid.

39 Walter Benjamin, quoted in Abrioux, as at note 37, p. 165.

40 Abrioux, as at note 37, p. 241; the original quotation is in Panofsky, as at note 6, p. 346.

41 Finlay to Reinhardt, 24 July 1964; quoted in Corris as at note 37, p. 198, n. 19.

42 Author's notes, as at note 16.

43 Letter, Finlay to Ronnie Duncan, 1 May 1979, in Ian Hamilton Finlay Papers, 1948–92, Getty Research Institute, Research Library, accession no. 890144, box 3, folder 5 (hereafter Finlay Papers, GRI).

44 Finlay to Lax, quoted in Corris, as at note 37, p. 113.

45 Letter, Finlay to Ronnie Duncan, 23 March 1977, Finlay Papers, GRI, box 3, folder 1.

46 Letter, Finlay to Tom and Laurie Clark, 24 August 1977, Finlay Papers, GRI, box 3, folder 1.

47 The recent acquisition of Finlay's house and library by the Little Sparta Trust will extend this possibility.

48 J. Dixon Hunt, as at note 3, p. 15.

49 P. Eyres, 'Naturalizing Neoclassicism: Little Sparta and the Public Gardens of Ian Hamilton Finlay', in Eyres and F. Russell (eds.), *Art and the Garden*, Aldershot, Ashgate, 2006, p. 177.

50 See C. Owens, 'Earthwords', *October*, no. 10, Fall 1979, pp. 121–30.

51 R. Long, 'Words After the Fact' (1982), reprinted in Tufnell, as at note 9, p. 26 with strange, fortuitous(?) mis-spelling of 'complimentary'.

52 Finlay, statement for *British Artists Books: A Survey 1983–93*, Estamp, 1993, quoted in J. Janssen, 'From the Arcadian Cardboard Forest', *Chapman Magazine*, nos. 78/79, 1994, p. 72.

53 Tufnell, as at note 9.

54 R. Long, *Five, six, pick up sticks Seven, eight, lay them straight*, Anthony d'Offay, London, 1980, reprinted ibid., pp. 15–21.

55 Long, as at note 30, p. 15.

56 Eyres, as at note 49, p. 171.

57 *Richard Long: Heaven and Earth*, Tate Britain, London, 3 June – 6 September 2009, p. 72.

CONTRIBUTORS

JOSEPH BLACK

Joseph Black is an artist and writer based in London. He obtained a Masters Degree in the History of Art from the Courtauld Institute of Art in 2016. He has since founded and continues to work as Senior Curator at Aganippe Arts. His work has been exhibited in independent curatorial projects across London.

STEPHEN BANN

Stephen Bann was Professor of the History of Art at Bristol University from 2000 to 2008, and is currently a Senior Research Fellow there. Professor Bann joined the University of Kent in 1967 as Lecturer in History and, during this time, was Deputy Editor, then Editor, of 20th Century Studies. He was subsequently appointed Professor of Modern Cultural Studies at the University of Kent, where he was also Honorary Professor from 2010 to 2014, before becoming Chair in History of Art at the University of Bristol. He has been appointed Slade Professor of Fine Art, University of Cambridge, for 2017–18. Since 2008, he has also served as a guest curator for major exhibitions at the National Gallery in London and the Musée des Beaux-Arts in Lyon. He was elected Fellow of the British Academy in 1998 and appointed CBE for services to Art History in 2004. He first met Ian Hamilton Finlay in 1964, and became (in the words of Finlay's son Alec) his "preferred commentator".

JOHN DIXON HUNT

John Dixon Hunt is Emeritus Professor of the History and Theory of Landscape in the Department of Landscape Architecture at the University of Pennsylvania's School of Design. In May 2000 he was named Chevalier of the Order of Arts and Letters by the French Ministry of Culture, and he was awarded an honorary degree of Doctor of Letters by the University of Bristol in 2006. Professor Hunt is widely considered one of the foremost of today's writers on the history and theory of gardens and landscape architecture. He is the author of numerous articles and books on gardening theory, including a catalogue of the landscape drawings of William Kent, *Garden and Grove,*

Gardens and the Picturesque, The Picturesque Garden in Europe (2002), *The Afterlife of Gardens* (2004), and *A World of Gardens* (2012). He edited the journal *Word & Image* from 1985 to 2010 and currently edits *Studies in the History of Gardens and Designed Landscapes.*

JOHN STATHATOS

John Stathatos is a photographer and writer. His interest in landscape led to a friendship with Ian Hamilton Finlay, as a result of which he photographed the garden at Little Sparta on several occasions, particularly during the 1980s. His work has been exhibited in many European venues, and has been a regular correspondent of major photographic and visual art magazines. In 1997 he curated the influential survey exhibition *Image & Icon: The New Greek Photography*, which toured internationally. Since 2002 he has been based in the island of Kythera, where he founded the annual Kythera Photographic Encounters. His publications include *A Vindication of Tlön: Photography & the Fantastic* (2001); *Fotofraktis: The Photographs of Andreas Embirikos* (2004); *The Book of Lost Cities* (2006); and *airs, waters, places* (2009).

JOY SLEEMAN

Joy Sleeman studied History of Art at University College London and has a PhD from the University of Leeds, Department of Fine Art. Her research embraces aspects of the histories of sculpture and landscape and these two areas of interest coalesce in her work on the new forms of landscape art that emerged in the 1960s, often referred to as 'Land Art'. Sleeman's work on land art includes a major exhibition, *Uncommon Ground: Land Art in Britain 1966–1979*, co-curated with Nicholas Alfrey (Nottingham University) and Ben Tufnell (independent curator and writer). Since 2000 she has been a member of the editorial board of *Sculpture Journal*, the leading academic journal for research in sculpture.

PHOTOGRAPHIC CREDITS

Front cover and pp. 2–3 photographs © Peter Austin
Back cover © Gary Hincks

Figs. 1, 4–8, 10, 13, 14, 16, 22, 23 © Joseph Black
Fig. 2 © Estate of Ian Hamilton Finlay
Fig. 3 © Stephen Bann
Fig. 9 © Vintage Maps
Figs. 11, 17, p. 124 © Cerys Willoughby
Fig. 12 © National Trust
Fig. 15 © Peter Austin
Fig. 18 © Reproduced by permission of the Trustees of the Chatsworth Settlement
Figs. 19, 35 © RMN/Guillaume Horen
Fig. 20 © Mike Forsyth
Figs. 21, 28–32 © John Stathatos
LYRE (2017) © Gary Hincks
A VIEW TO THE TEMPLE (2017) © Gary Hincks
APHRODITE OF THE PASTORAL (2017) © Gary Hincks
Fig. 24 © John Dixon Hunt
Figs. 25, 33 © Tim Harland
Fig. 26 © Michael MacLean
Fig. 27 © Neil Astley
Figs. 34, 37, 39, 40 Courtesy the artist (photo: Haunch of Venison, London; © the artist)
Fig. 36 © New Arcadian Press
Fig. 38 photo: Scottish National Gallery of Modern Art, Edinburgh (© the artist)
page 132 ©Sneeboer & ZN

ACKNOWLEDGEMENTS

My initial acknowledgements should naturally go to the talented and brilliant contributors to this book – Gary Hincks, John Dixon Hunt, John Stathatos, Joy Sleeman – and to Stephen Bann, whose work in and beyond this publication has been of tremendous help and inspiration, and also to all the photographers who have submitted their beautiful work.

Furthermore I could not have completed this work without the support of those who were able to lend their help along the way: William Allen (William Allen Word & Image), Patrick Eyres (Director of the New Arcadian Press), Nick Morris (Chief Executive Officer of Stowe House Preservation Trust), Pia Maria Simig (The Estate of Ian Hamilton Finlay), Caroline South (Aganippe Arts), Deborah Swallow (Director of the Courtauld Institute of Art), Professor Sarah Wilson (Courtauld Institute of Art), and the designer and publisher of this book.

The production of this book has been sponsored by Proteome100 Ltd.

Sneeboer & ZN, Dibber (used for implanting seeds) (2016)